Photography by Larry Prosor
Text by Richard Moreno
Editing by A.D. Hopkins
Design by Sue Campbell

ISBN 1-93217-303-X

06  05  04  03      4  3  2  1

Printed in Hong Kong

Stephens
Press LLC

*A Stephens Media Group Company*
PO Box 1600, Las Vegas, Nevada 89125-1600
702-387-5260 / 702-387-2997 Fax
www.stephenspress.com

# ENDLESS
# NEVADA
## A PHOTO ESSAY

**Larry Prosor • Richard Moreno**

*Foreword by John L. Smith*

A CERCA BOOK

## Acknowledgements

The authors wish to acknowledge and thank the following people, who helped to make this book possible.

Greg Cichoski • Jim King
Robert Laxalt • Laurel Hilde Lippert
Silver and Bill Martin • Nicole Misfeldt
Pamela, Hank and Julia Moreno
Nevada Commission for Tourism
*Nevada Magazine* • Nadine Powers
Cindy, Whitney and Will Prosor
The Prunty Family • R & R Advertising
Ruby Mountain Heli Ski
Skydance Helicopters • Robert Stillwell
"The Professional Tourists" • Tom Radko
and the staff of the University of Nevada
Press • Jerry Vaughn • Nancy Nell Vaughn

For information regarding advertising use
or purchase of individual limited edition, signed
photographic prints from this book,
please contact:

*Larry Prosor Photography*
10715 Somerset Dr.
Truckee, California 96161
530-587-4736
www.nevadaimages.com
or email:lprosor@jps.net

*On the cover:* Autumn fishing in the Truckee
River.

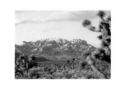
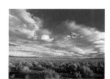
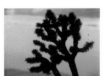

# CONTENTS

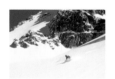

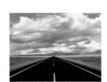

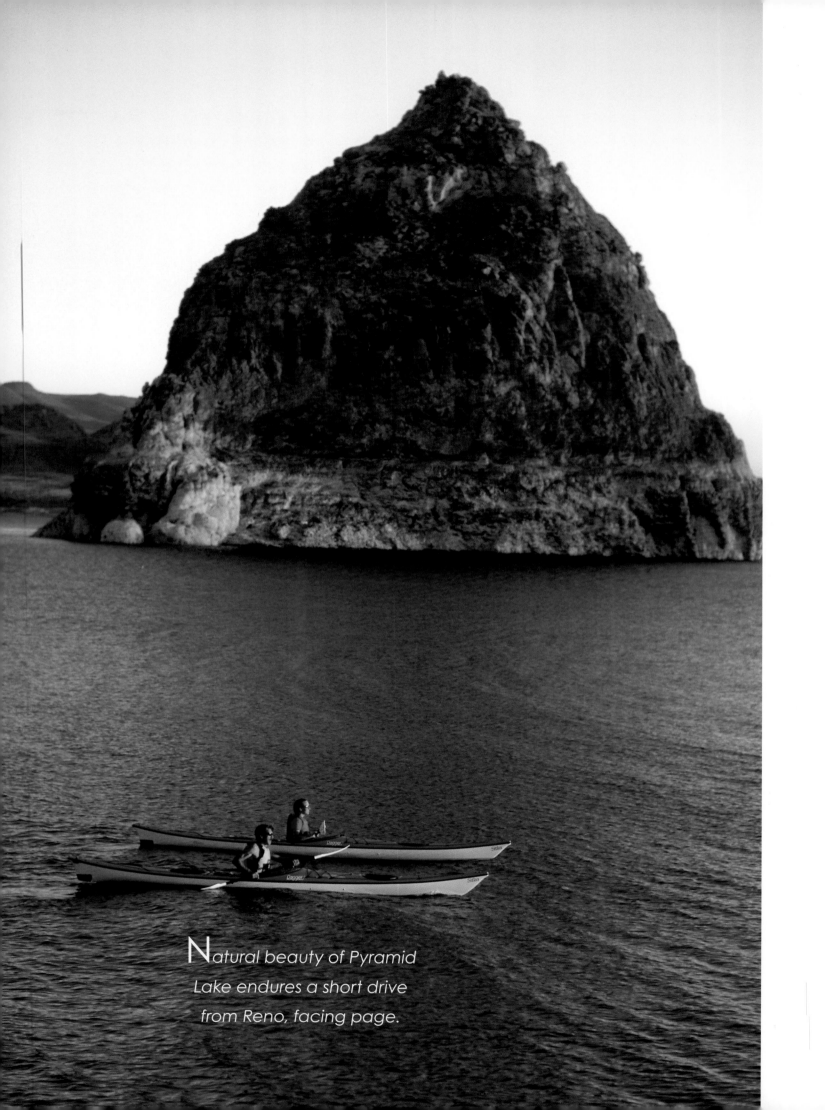

Natural beauty of Pyramid
Lake endures a short drive
from Reno, facing page.

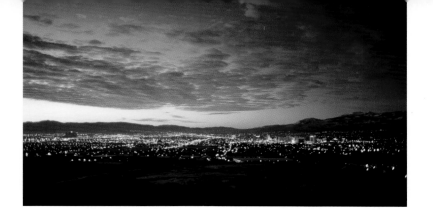

Foreword

## *John L. Smith*

# *Celebrating the Nevada Mystery*

Nevada has long been a place of endless mystery, irony, and flat-out wonderment for those who have taken time to experience it. It's easily the most eccentric and interesting state in the union. Of course, if you suspect I am biased on this subject, you're right: I love Nevada from Searchlight to Jackpot and every quirky roadside rest and heartachingly beautiful panorama in between.

I'll wager a month's pay that photographer Larry Prosor and writer Richard Moreno love it, too. Fortunately for us, they are here to help the tenderfoot and neophyte solve some of the mysteries and appreciate the ironies of this land of subtle beauty and endless sky. Consider them experienced sleuths in

this regard, for Prosor and Moreno sport decades of first-hand experience in this incredible country. You would be hard pressed to find more capable guides.

Through the generations, Nevada's snow-shrouded mountains and sun-baked deserts have drawn endless waves of immigrants seeking a foothold in America. More often than not, they found their new freedom in the form of honest sweat and back-breaking toil. Of course, Nevada has also attracted its share of outlaws and eccentrics, spiritualists and dreamers—especially dreamers. For dreamers and second-chance seekers, Nevada stretches out like a vast canvas of endless possibility and ample opportunity.

What is Las Vegas, after all, but a dazzling dreamscape, come-to-life in the middle of the desert? Its lusty architectural overstatement and celebration of excess speak to uniquely Nevada themes. Around these parts, they say anything worth doing is worth overdoing.

And what were the gold and silver fields of more than a century ago but magnets for dreamers with strong backs and questionable sense? Prospectors chased riches beyond their wildest dreams here. From Gold Hill to Silver Peak, the high-grade ore held the promise of wealth for those tough enough to endure harsh summers and bitter winters. The lucky found an emigrant's El Dorado and filled their pockets to bulging. The others moved on or found their eternal rest not far from their played-out claims. Most of those dreamers' stories were written on the wind and, these days, echo through the dozens of ghost towns that dot the state.

Nevada's history is filled with tales of mining boom and bust, but today most of the

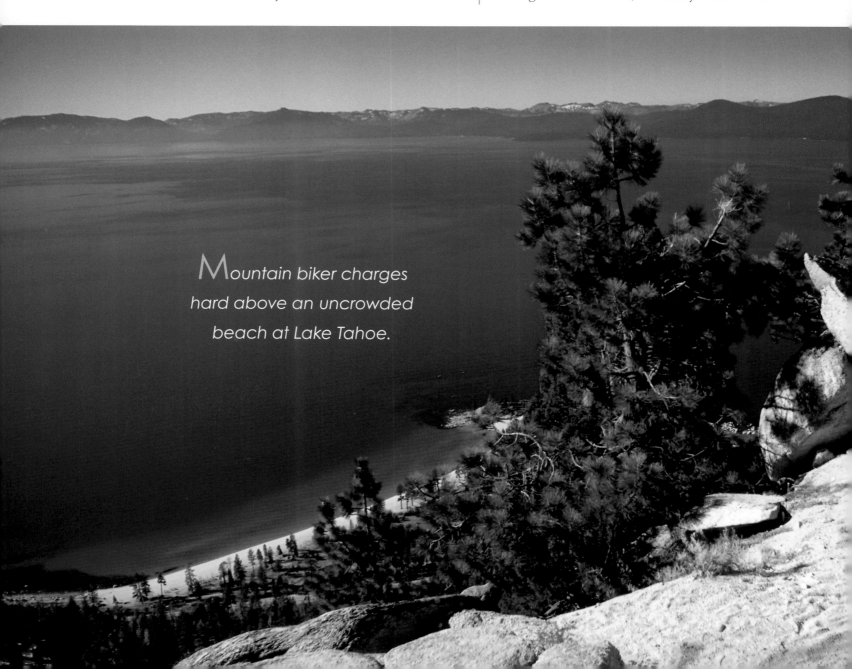

Mountain biker charges hard above an uncrowded beach at Lake Tahoe.

single-jack prospectors have been replaced by international corporations. No matter. Nevada is still in the mining business. California is called the Golden State, but the Silver State remains one of the world's top gold producers.

It is also a place of uncommon beauty. Anyone who has watched a desert sunset explode across the horizon in orange, red and lavender will never again call the Mojave or Black Rock a drab place. Anyone who has seen a herd of mule deer bust out of an aspen stand in the Ruby Mountains and rumble across the hillside can never again think of Nevada as a place without plentiful wildlife.

Minnesota may be the land of 10,000 lakes, but there's something particularly soothing to the eye about Lake Tahoe, the Truckee River, and the hundreds of springs and streams that reach like veins throughout the Great Basin. Water

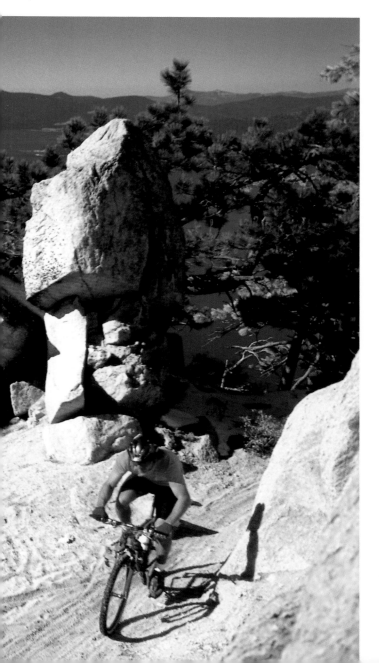

is another of the marvelous ironies of Nevada. Today, Nevada is the place a person will find the nation's fastest-growing urban area, Las Vegas, and the oldest living thing, the bristlecone pine. Only in Nevada will a visitor find one of the world's great dams, Hoover, creating one of the planet's largest manmade lakes, Mead, smack in the middle of one of the world's driest places, the Mojave.

You don't have to be touched to live here, partner, but it helps.

At times it appears all roads lead to Nevada. And what long, strange trips they are. The state is home to the Extraterrestrial Highway (State Route 375), America's Loneliest Road (US 50), one of the busiest stretches of asphalt in America (Interstate 15), and two of the most recognized thoroughfares in existence (Fremont Street and Las Vegas Boulevard).

As they turn the pages of this book, newcomers to the Nevada experience will feel their preconceived notions about the state turn to a dust finer than any that blows across the Mojave. Those who mistakenly believe Nevada is a flat, barren expanse of desert surely will marvel at the more than 200 mountain ranges that roll and jut through the state to peaks in excess of 13,000 feet. Don't tell Montana, but Nevada is America's most mountainous state.

Then there's the canard that Nevada is as parched as a prospector's gullet. But the same state that cradles the arid Mojave also boasts Lake Tahoe, one of the world's deepest and purest freshwater bodies. This rich, strange place of cactus and coyote supports the largest national forest in the lower 48 states, the 6.5 million-acre Humboldt-Toiyabe. Its sweeping pine and juniper expanses roll on mile after mile and provide a habitat for deer, pronghorn, and elk. Count the abundant forests and wildlife as two more wonders of this place.

With help from Prosor and Moreno, Nevada's mysteries will begin to unfold for you with color, depth, and literary precision.

It's the next best thing to taking to the open road and solving the mystery for yourself.

—John L. Smith
September 2002
Kyle Canyon

John L. Smith is a columnist for the *Las Vegas Review-Journal* and author of several books on Nevada.

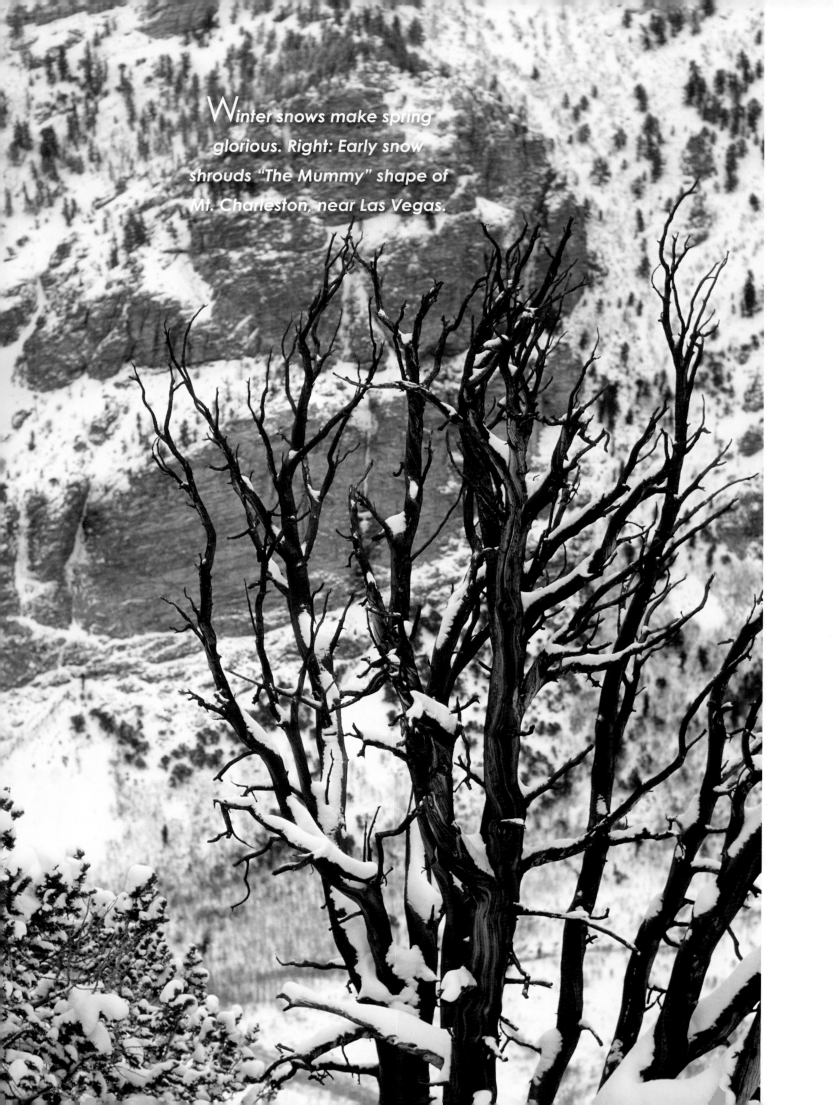

Winter snows make spring glorious. Right: Early snow shrouds "The Mummy" shape of Mt. Charleston, near Las Vegas.

# Introduction

## *Robert Laxalt*

(1923–2001)

As I read author Rich Moreno's prose and examined Larry Prosor's photographs, one thought kept running through my mind: what this book is saying is like a biblical simile. *In the beginning was the land and in the end there will remain only the land.*

The reader will know what I mean as he explores this book. Neither image nor prose strays far from the land. Geologic ages of volcanic eruption, searing sun and glacial cold come and go. Primitive man appears, lays his imprint gently with haunting petroglyphs and then fades into the mystery of oblivion. The white man comes and confronts the wilderness of desert and mountain as an enemy to be conquered. Emigrant trains and fortune-seeking successors

tear pell-mell across the forbidding desert sweeps with one thought in mind—to reach the green promised land of California as quickly as they can. The gold seekers curse the obstacles and the hardships of the land, their eyes only upon the treasure bearing rivers and streams of the Sierra. They come reluctantly back to the desolation of Nevada where silver makes any setting desirable, and then leave when they have plundered the land. They build myriad little mining camps and towns that live for a day or a handful of years before they begin to crumble into the enduring land that has been waiting to claim them. Only the hardy remain—cattlemen and sheepmen and town dwellers seeking a new beginning.

Author Rich Moreno and photographer Larry Prosor have probed nearly every nook and cranny of Nevada to find and chronicle the lives and visages of Nevadans gone and Nevadans present. They find beauty not in violent landscape but in hues so subtle that they seem not to exist.

They find man's presence in ways that reveal how very temporal it is. They miss practically nothing in unfolding the story of Nevada. And when the story is done, they conclude that when humanity has had its day in the sun, the land will be waiting still.

*Robert Laxalt was Nevada's outstanding literary figure of the 20th century. Author of 17 books, he captured the state both in novels and non-fiction.*

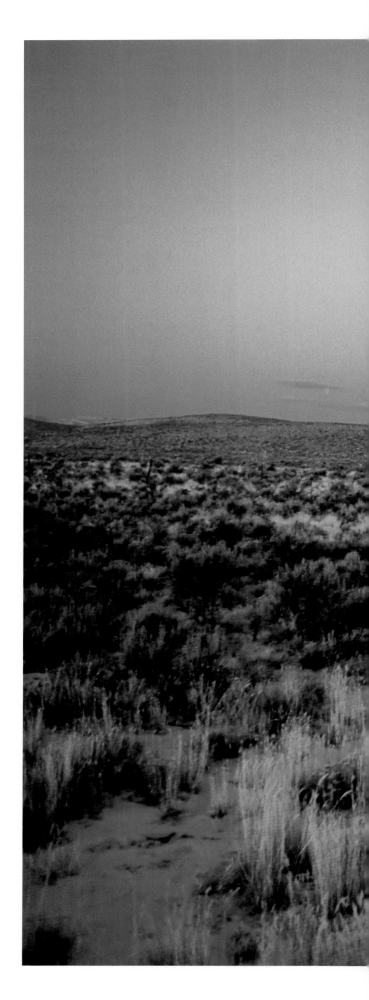

*Moonset over the Independence Range.*

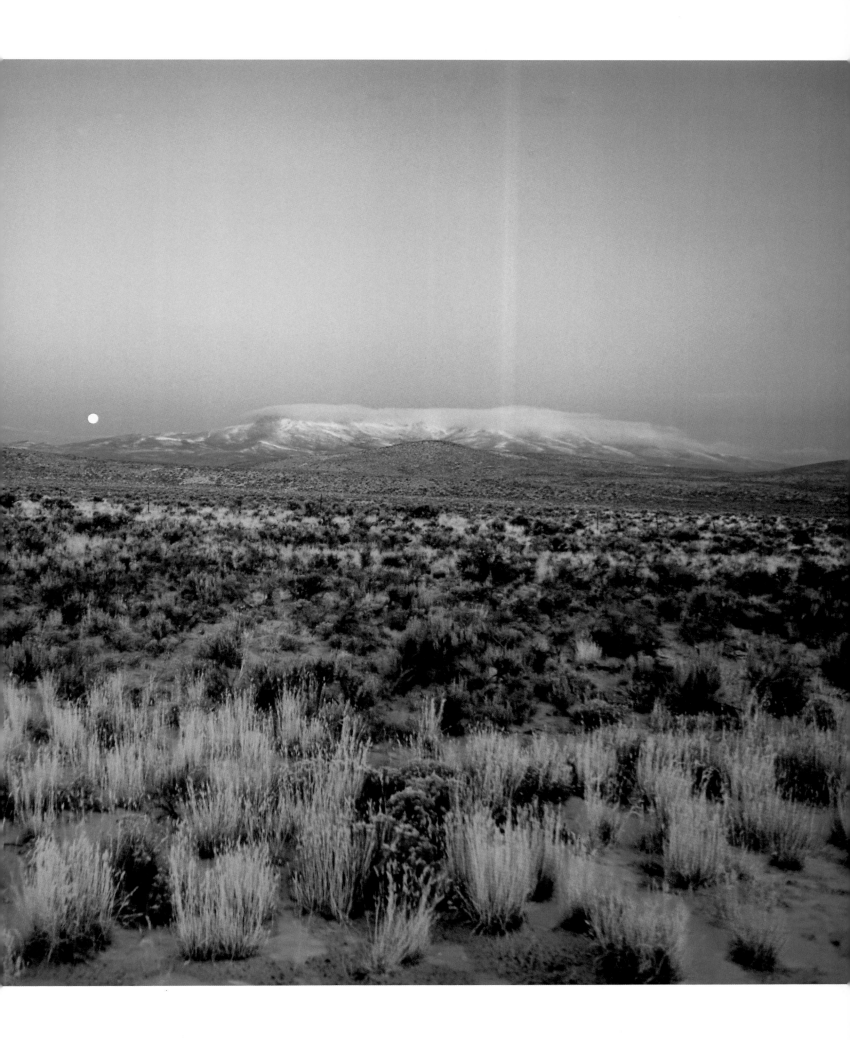

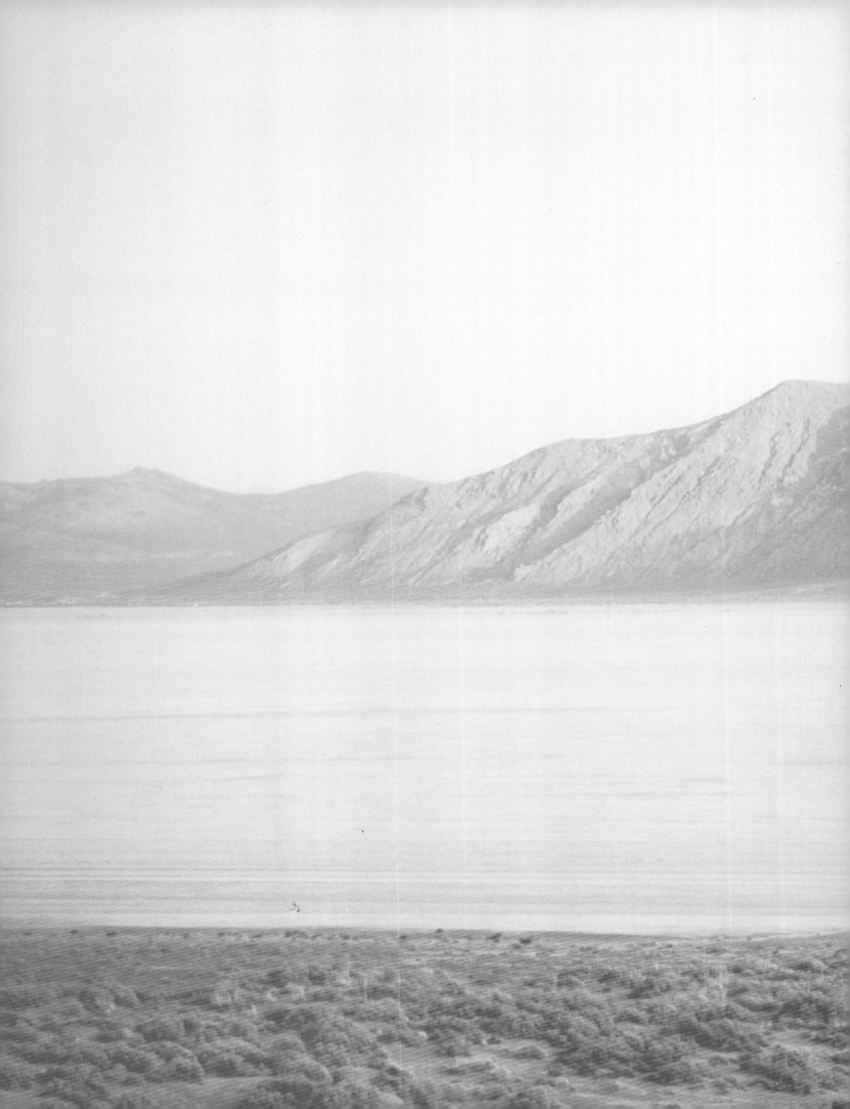

# OVERVIEW

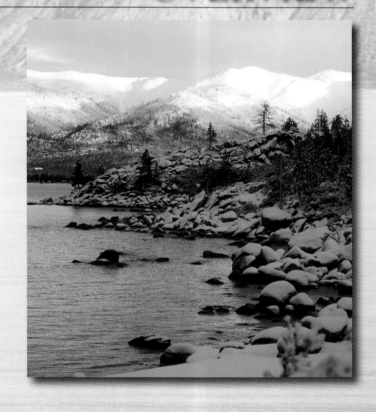

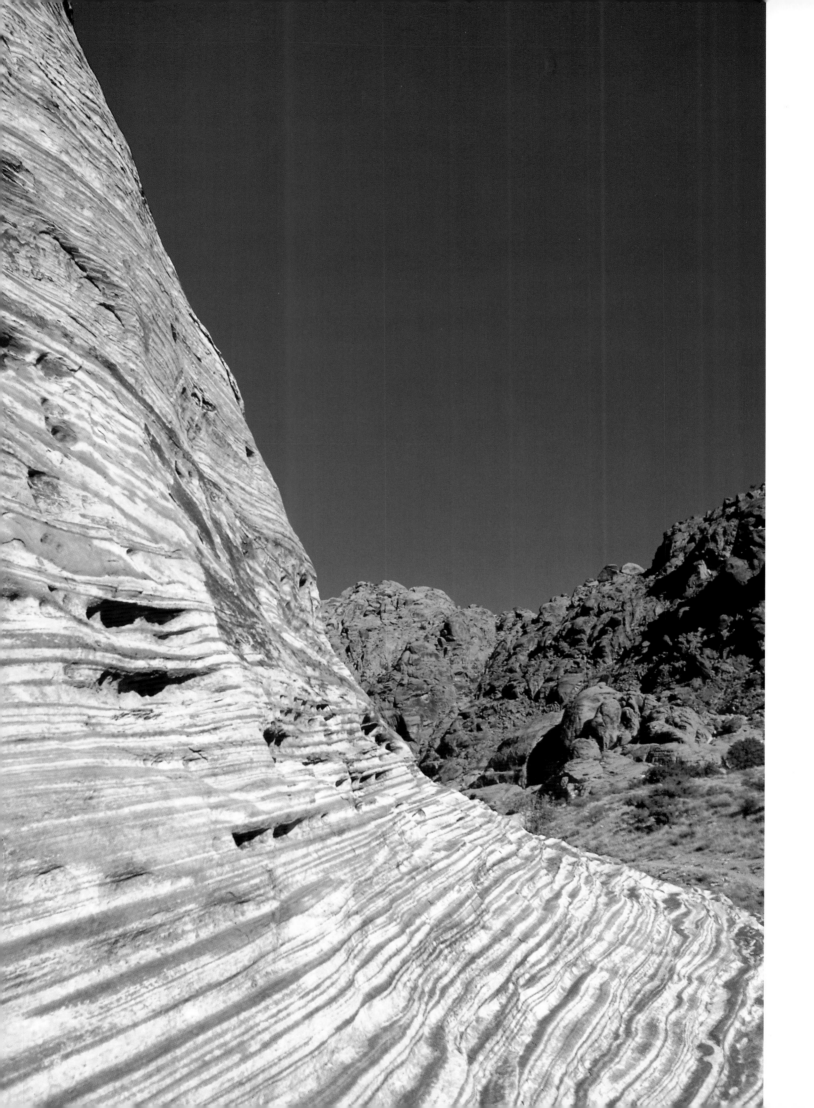

> *"Hidden between the pages was a single sprig of Nevada sagebrush. Before I could protect myself, the memories were summoned up and washed over me in a flood."*
> —Robert Laxalt

For more than a century and a quarter, Nevada has charmed, disturbed, perplexed and, to borrow a word from former Nevadan Mark Twain, "bamboozled" those who would try to fit it into some neat definition. It is a place that has been described as both a "vacant sunburnt space between the gambling ghettos and the Mormon Tabernacle Choir" and a "beautiful desert of buried hopes."

Literally, Nevada is a trapezoid-shaped piece of the American West, bordered by California, Oregon, Idaho, Utah, and Arizona. The seventh largest state, it encompasses 110,540 square miles and is 485 miles long, 315 miles wide.

While it has more than two hundred mountain ranges, it is the driest state with an average rainfall of less than 9 inches. Altitudes range from over 13,000 feet to less than 1,000 feet. Average annual daily temperatures range from 70 degrees Fahrenheit in the south to 45 degrees in the north.

To the early explorers, it was "the great unknown" and a place to be avoided, while in recent years it has been looked upon as a wasteland suitable only for the nation's nuclear garbage. With its miles of open, untamed, seemingly vacant landscape, it's easy to understand why, at first, some might not recognize the unique beauty found in Nevada.

But Nevada has a way of changing a person. What once may have looked like a big, empty desert valley, in time, becomes a complex, thriving community of sagebrush, piñon trees, rice grass, and hundreds of other plants, animals, and insects. What once may have seemed merely a lonely evening sky transforms into a visual feast of rich, purple-red hues, later replaced by a bright moon that casts a luminous beauty over the desert. What once appeared to be some remote, boring, backwater town turns out to contain hidden treasures of fascinating characters, history and scenery.

There are plenty of reasons why Nevada is the way it is. Over the past half-billion years, the land now called Nevada has been submerged under a sea, dried out under an unbearably hot sun, plunged back under water, lifted out, squeezed, folded, sand-blasted, cooked by lava, buried under volcanic ash, covered with ice, and more water, before finally drying out and becoming what it is today. You'll have to agree that it's tough to maintain a sunny disposition after all that.

Valley of Fire in southeastern Nevada.

Modern Nevada began to take shape about 15 million years ago, during one of those seemingly endless upheavals. During this time, called the Miocene Epoch, the continental plates under the land began to shift, lifting the crust upward. This action caused the surface to pull apart, then slide together, ultimately creating more than 200 mountain ridges in the state, as well as many magnificent, wide valleys. The ranges and valleys are generally 50 to 100 miles long. Later, some 10 million years ago, the Sierra Nevada, which constitutes the region's western border, underwent one final uplifting, which placed everything east of the range in its climatic shadow, creating a desert.

One of the first non-native visitors to the region, John C. Fremont, erroneously named it the "Great Basin" upon seeing that its rivers drained into lakes or evaporated into sinks and did not flow to an ocean like most other rivers. The reality, however, is that rather than being a giant bowl ringed by mountains, Nevada's surface is a washboard of hundreds of ridges and depressions, nearly all running north to south—but the "Great Washboard" doesn't quite have the same ring as the "Great Basin."

Archaeology suggests people occupied the region about 12,000 years ago, just as the great lakes covering the state were beginning to recede. Prehistoric rock writings, called petroglyphs, have been found at more than 1,000 sites throughout the state. While the exact meaning of these stone designs has never been determined, petroglyphs have been found dating more than 5,000 years old.

A more sophisticated Indian culture began to develop in southern Nevada after 2,500 B.C. Initially foragers who traveled in small bands, these early emigrants (who most likely spread into Nevada from the southwest) subsisted on

such fare as desert tortoise, jack rabbits, and mesquite beans.

About 300 B.C., the Anasazi appeared on the Nevada scene, bringing more evolved skills such as basketmaking and the ability to construct pit houses, which were holes dug in the ground , then roofed with brush and grass. Within a few hundred years, the Anasazi began developing communities in which many members of the tribe lived close to one another, hunted and gathered together and built homes of adobe.

The Anasazi disappeared about 1150, perhaps as the result of a severe drought or epidemic. This coincided with the emergence of the Southern Paiute (who lived in southern and southeastern Nevada), as well as the related Western Shoshone (eastern, central and northeastern Nevada) and Northern Paiute (northwest and western Nevada). A fourth group, the Washoe, roamed parts of western Nevada and eastern California (Honey Lake to Sonora Pass to the Virginia City area). With a language and culture different from those of its Nevada neighbors, the Washoe tribe was more closely related to the Miwok Indians of eastern California.

*"Great Washboard doesn't quite have the same ring as the Great Basin."*

Not surprisingly, their environment dictated the lifestyles of Nevada's tribes. Since survival depended on following seasonal harvests, fishing and hunting, Nevada's native people did not construct permanent homes or develop sophisticated agriculture. Dwellings usually consisted of temporary structures made of poles covered with reeds, branches and grass. The exception was in winter when tribes would relocate to more sheltered valleys and construct grass or bark dwellings.

### Early Explorations

While Nevada's native people were able to maintain a tenuous balance with their environment in order to survive, the arrival of the white man ("Taibo" in the Paiute language) ultimately presented a far greater threat to their continued existence.

The first visitor is believed to have been Father Francisco Garces, although some question whether he traveled quite far enough north to cross the boundaries of the modern state. In the spring of 1776, Garces and two Indian guides split off from a larger expedition force led by Captain Juan Bautista de Anza, to seek a more direct route from Santa Fe to Monterey. Garces crossed the Colorado River near the southern tip of the state and found his way to the California mission, San Gabriel, establishing the western end of what would become the principal trail across the Mojave Desert.

The first major non-Indian penetrations into the region occurred in 1826, when Jedediah Smith and Peter Skene Ogden led two expeditions. Representing rival fur companies, both were also searching for the mythical San Buenaventura River, a waterway that was believed to drain Western rivers into the Pacific Ocean.

Smith, of the American-owned Rocky Mountain Fur Company, led his party through southern Nevada, spent the winter in California, then returned in the spring over the Sierra Nevada range, before surviving a trek across central Nevada. The group's trip was significant because it was the first to cross the wide expanse of the Great Basin as well as call into question the existence of the San Buenaventura River.

That same year, Ogden, who worked for the British-owned Hudson's Bay Company, led a party into the future Silver State from the north, trapping beaver along the Owyhee and Bruneau Rivers. In the fall of 1828, he set out from Oregon, entering Nevada near present-day Denio, and continued south by southeast until he encountered a river (the Humboldt, which he named "Unknown River").

His group headed east to Salt Lake City due to the coming winter months, passing near the future site of Elko. The following spring, Ogden returned to Nevada in search of more beaver pelts and explored much of northeastern Nevada before heading west along the Humboldt River, eventually reaching the Humboldt Sink. He returned to Oregon and concluded this expedition in the summer of 1829, but was back in Nevada that fall, retracing his trail along the Humboldt River to the Humboldt Sink, then heading south to present Walker Lake and continuing into

California. Of course, he found no inland river leading to the Pacific Ocean.

In the winter of 1829-30, New Mexico merchant Antonio Armijo crossed Southern Nevada, finding a path connecting , in Eastern California, to the trail already found by Garces and Smith. This complete path fulfilled the long-standing dream of a practical land trade route from Santa Fe to the California missions, and became the famous "Old Spanish Trail."

The next forays into the region occurred in the early 1830s with the explorations of the Captain Joseph Walker party, which retraced Odgen's route to the Humboldt Sink, before crossing the Sierra near present Bridgeport. On the return trip, Walker's group crossed into Nevada farther south and traveled north to the Humboldt Sink. After following the Humboldt River as far east as Wells, the party ventured northeast, establishing a route that became part of the California Trail.

### Early Emigrants

Word of these early successful crossings of the region and excitement over the economic opportunities to be found in California, ignited the imaginations of a number of individuals, including Missouri schoolteacher John Bidwell, who formed the Western Emigration Society.

In 1841, Bidwell, along with John Bartleson, and other families eager for new opportunities, set out for California. The large group arrived at Soda Springs on Idaho's Bear River, then split into smaller parties, each choosing a different route. Some of the emigrants changed their plans and headed for Oregon, while the Bidwell-Bartleson group struck out southwest into the Great Salt Flats and Nevada. While making many mistakes during the journey, and barely surviving, the party managed to arrive in California about six months after departing Missouri and established overland travel to the West. A second group, the Walker-Chiles party, traveled a slightly different route in 1843, largely avoiding the salt flats, and arrived in California nearly intact.

Large scale migration to the West followed the highly-publicized explorations of Captain John C. Fremont. From 1843 to 1853, Fremont teams of explorers, including Kit Carson, made several trips into northern, central and southern Nevada, mapping much of the state and providing lasting names to many landmarks, ranging from Pyramid Lake to the Humboldt River.

Fremont's widely circulated report to Congress, following his 1843-44 and 1845 journeys, included the first accurate maps of the region and provided the tangible proof—which was heavily biased by Fremont's firm belief in "manifest destiny" and his desire to settle the West—that many needed before attempting the treacherous journey to California. Starting in 1846, with the ill-fated Donner Party, hundreds of caravans of wagons, horses and people began heading west.

The Donner Party departed Independence, Missouri, for California on May 5, 1846. Originally part of a larger group, the Donner Party of 87 men, women and children, split off to follow a "short cut," called the Hastings Cutoff. But because these travelers were tenderfeet without experienced guides, the "short cut" actually delayed them.

The party finally reached the Truckee Meadows area (future site of Reno) in October. After resting, the group attempted to cross the Sierra Nevada just at the onset of one of the worst winters in history. A nearly continuous series of heavy snowstorms trapped the travelers near the shores of Donner Lake, where they were forced to spend weeks without supplies. By the time relief parties finally arrived from California, forty of the original party had perished.

### The Gold Seekers

Despite the Donner legacy, the discovery of gold in California in January 1848, finally opened wide the floodgates. Within months, thousands of emigrants were crossing Nevada to reach the California gold fields. Naturally, all these people required services and, within a short time, a series of trading posts and stations began appearing in Nevada.

The first significant Nevada post was established in 1850 near the eastern edge of the Sierra. This first post, really little more than a crude log cabin, was erected by Captain Joseph DeMont and Hampton S. Beatie. The two later sold their business to a man named Moore, who, in turn, sold the cabin post to John Reese, a Mormon trader from Salt Lake City. Reese built a larger log structure, which became known as

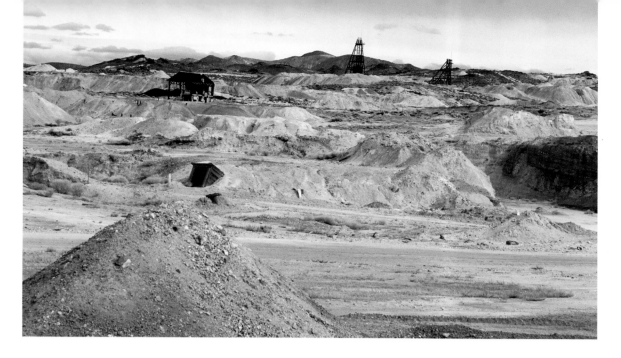

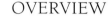

$M$ine tailings are all that remain of Goldfield's rich diggings.

the Mormon Station. This building has been recognized as the first permanent structure in the first permanent settlement in the future state of Nevada.

At the same time this small community was developing at the place now called Genoa, California-bound miners were finding specks of gold in the mountains east of the Truckee Meadows. By 1850, several dozen prospectors were working the area that became known as Gold Canyon, in the shadow of Sun Mountain. Small mining operations continued in the region until 1859 brought the discovery of the fabulous Comstock Lode.

While two brothers, Hosea and Ethan Allen Grosh, had recognized silver potential in the Gold Canyon area in 1857, it wasn't until two years later that Patrick McLaughlin and Peter O'Riley began uncovering the massive silver deposits of the Comstock Lode.

As with many of those who were first with a major mining strike, McLaughlin and O'Riley didn't benefit much from their discovery. Another miner, Henry Comstock, said he had an earlier right to the claim—most likely a lie—and gained a share of the McLaughlin-O'Riley find. In the end, it was his name that became indelibly linked with the area's huge mineral reserves.

News of the Comstock Lode spread gradually during the next months until, by 1860, thousands were making the "rush to Washoe," as it became known. A handful of mining camps were established on the slopes of Sun Mountain, including Virginia City, Gold Hill and Silver City. By 1863, an estimated 15,000 people were residing in Virginia City.

## Development of the State

During this same time, various attempts were made to establish some kind of governmental structure in Nevada. Initially, the area was part of the Utah Territory but that arrangement proved unsatisfactory because of the great distances to the territorial seat in Salt Lake City. After a failed attempt at unsanctioned home rule, Congress created the Nevada Territory in March 1861. President Abraham Lincoln named James Nye of New York as governor. A territorial legislature was elected in August 1861 and met three times during the subsequent four years to establish civil and criminal laws, revenue measures, state boundaries, and the other minutae of government.

In 1863, a constitutional convention was called to craft a document that would allow statehood. While a statewide election to approve the constitution was defeated in January 1864, enabling legislation creating the state was approved by Congress and the president on March 21, 1864. A second constitutional convention was held from July 4 through July 27, and another constitution was drafted. This version, which revised a controversial mining tax that had doomed the earlier model, was

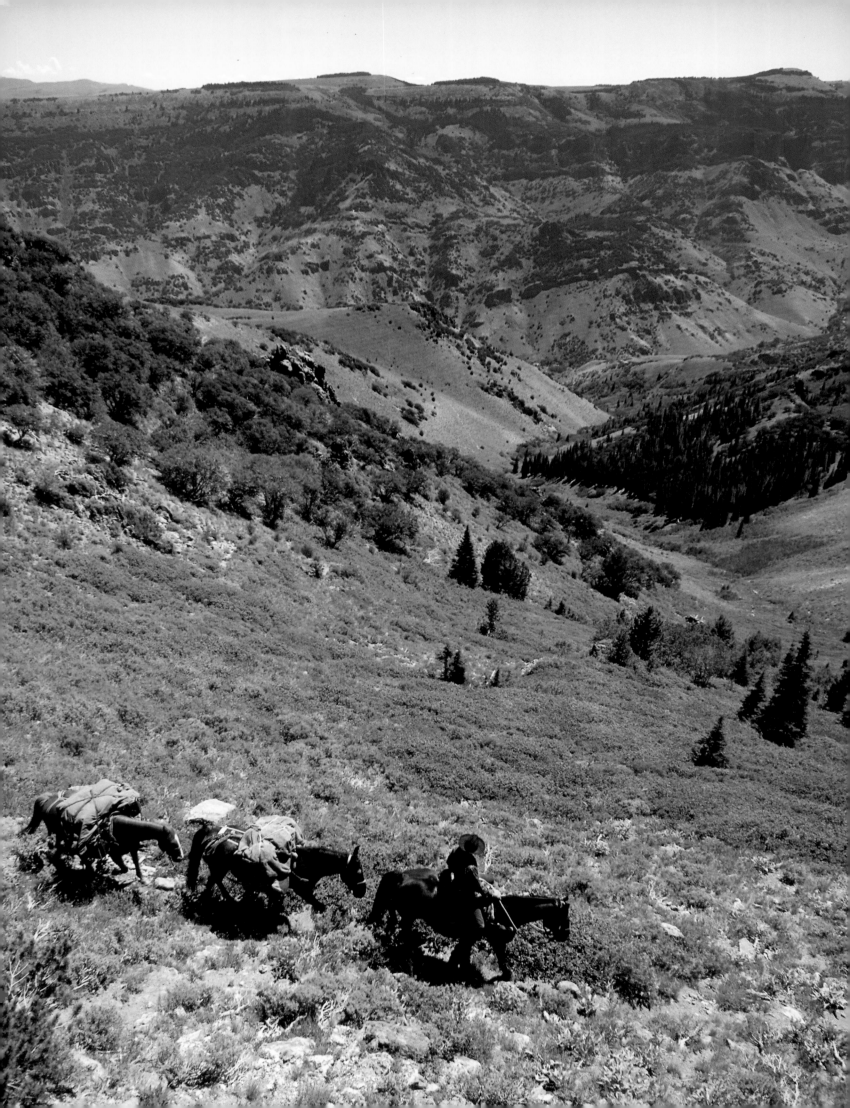

approved on September 7, 1864, by a margin of nearly ten to one.

On October 3, 1864, two copies of the constitution were sent to Washington, one via overland stage, and the other by steamship and rail. According to Nevada historian Phillip Earl, however, neither had arrived in Washington by October 24. Since the enabling act required the president to have a copy to officially read into the record before issuing a proclamation of statehood, on October 26, statehood supporters decided to telegraph the 16,500-word document to President Lincoln—a task that required 12 hours of telegraph time at a cost of $3,426. On October 31, 1864, President Lincoln issued the proclamation and welcomed Nevada as the 36th state.

For the next 15 years, the fortunes of Nevada largely ebbed and flowed with those of the Comstock. While other mining districts would be created and newer towns would rise in other parts of the state, such as Austin, Belmont, and Hamilton, the Comstock would contribute nearly two-thirds of the state's total mining production from 1859 to 1880. It was no surprise that, after nearly all of Virginia City was destroyed by fire in 1875, and mines declined soon thereafter creating statewide depression, some speculated that perhaps Nevada did not deserve statehood.

Nevada's savior proved to be a rancher and sometime miner named Jim Butler, who on May 19, 1900, stumbled upon one of the largest gold and silver discoveries of the 20th century at a place in central Nevada called Tonopah. A colorful legend has developed that says Butler's mule led him to the rich ledges at Tonopah (a Paiute name meaning "brush water," for springs found in the area). Regardless of the truth, Butler did find and file the original claims in the region and, with the help of mining lawyer Tasker Oddie (later elected governor and to the U.S. Senate) and science teacher Walter Gayhart, identified the mineral reserves.

Within months, thousands of miners had flocked to Tonopah to make their fortunes. Two years later, additional vast gold and silver deposits were uncovered about 25 miles south of Tonopah at a place eventually named Goldfield (and, in 1907, at Rhyolite). At nearly the same time, huge copper deposits were discovered in far eastern Nevada, near the town of Ely.

These major strikes at Tonopah and Goldfield helped pull the state out of the economic doldrums it suffered in the late 19th century, and also shifted political and economic power to central Nevada. Yet both mining communities eventually became victims of the mining rollercoaster. By 1908, both would boast fine hotels, newspapers, dozens of substantial brick buildings, fine homes, churches and schools. And, less than a decade later, when the ore had largely run out, both would have experienced rapid declines that threatened their viability as communities. Indeed, of the early 20th century mining boomtowns, only Ely, which had not developed as quickly or as extravagantly as its sister communities, would escape the next significant Nevada depression, during the 1920s and 1930s. Its copper reserves proved more long-lived, lasting into the 1990s.

## Gambling

In 1931, Nevada Assemblyman Phil Tobin, a Winnemucca area rancher, introduced legislation to legalize gambling in the state. While most forms of gambling had been accepted over the years—largely as a hold-over from the wide open mining camps—it had all been declared illegal in 1910. (Some card games, where the deal was alternated, were made an exception in 1915.) But enforcement of the laws was uneven at best. Tobin believed that much of the illegal gambling money was going out of state. He reasoned that legal games would help keep the money at home where it could be put to better use.

Tobin's bill was quickly approved by the state legislature and signed by Governor Fred Balzar on March 19, 1931. On the same day, Governor Balzar also signed into law a bill lowering divorce residency from three months to six weeks.

You could say that modern Nevada was born that day.

*Jarbidge Wilderness remains kind of country which lured trappers to explore.*

Lying at the base of Cougar Peak, Emerald Lake is a gem worth discovering.
Inset: Well-adapted to its life in the desert, a large Joshua tree reaches out to the sun.

# THE LAND

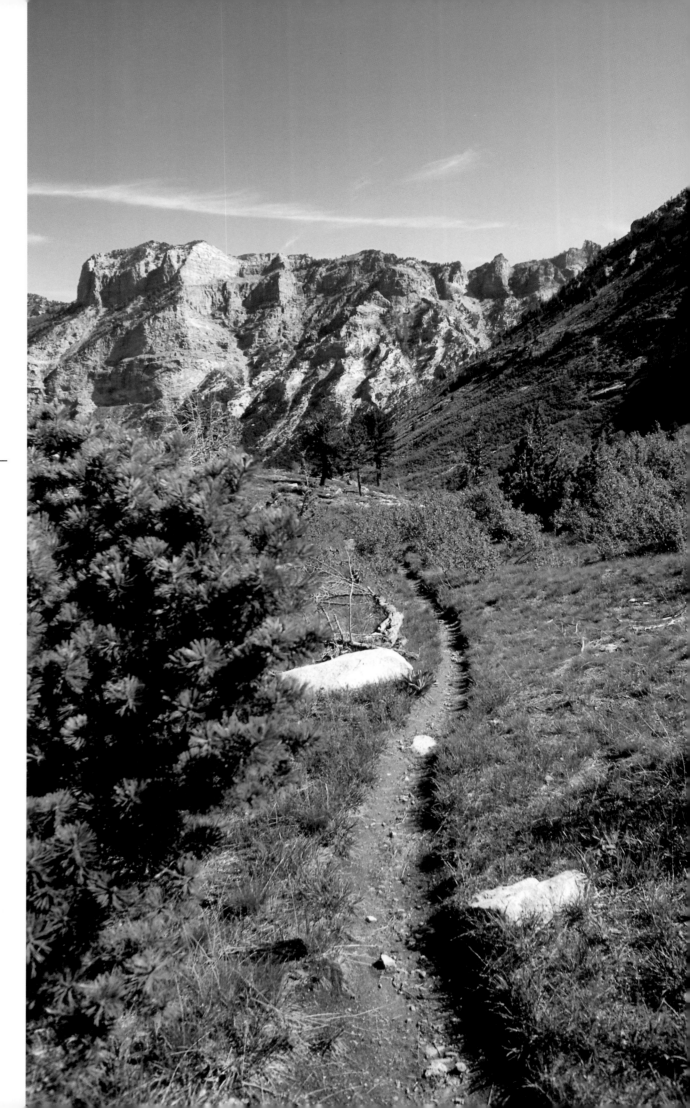

THE LAND

26

*Nothing clears the mind like walking down a trail such as this in Thomas Canyon, Elko County. Below: The highest point in Nevada, at 13,140 feet, Boundary Peak lies along the California border in the White Mountains.*

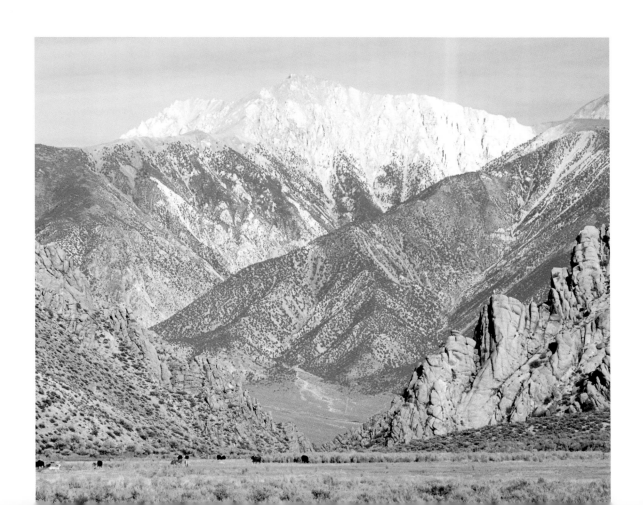

Pyramid Lake was once a part of a vast lake that covered an enormous expanse of the Great Basin.

Sailing along on a sea of alkali, at Black Rock Desert.

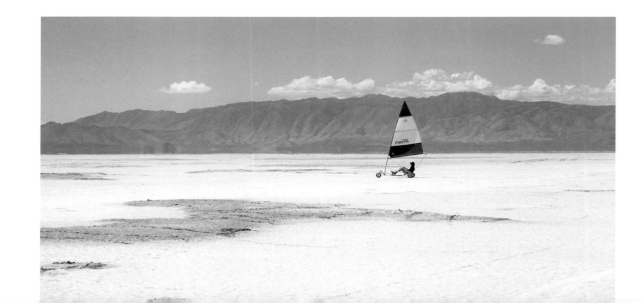

*An essential landmark for thousands of settlers moving westward was the "Black Rock." Here in a broad expanse of arid land, was a welcome oasis.*

*W*ater is a precious commodity
in some parts of Nevada but
abundant in others, such as
the Ruby Mountains. Below:
Cathedral Gorge continues to
change with forces of erosion.

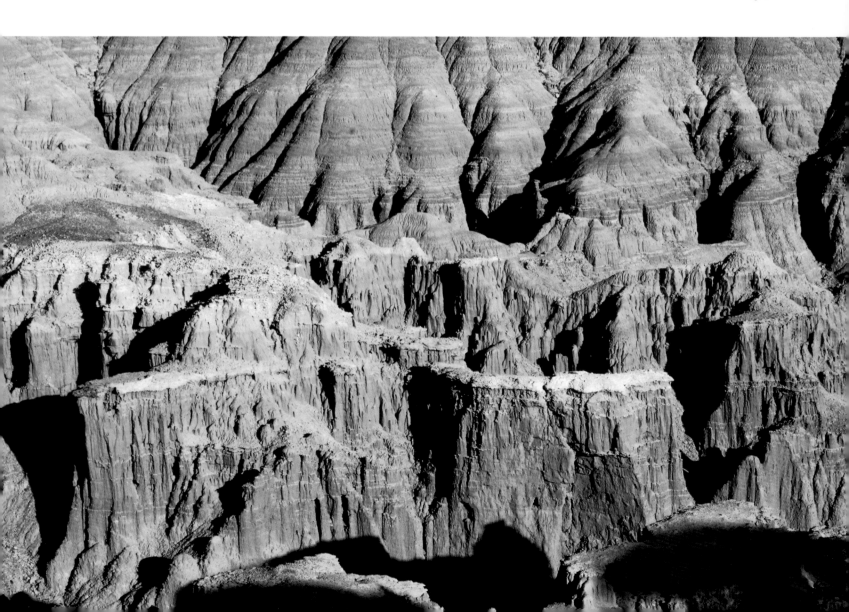

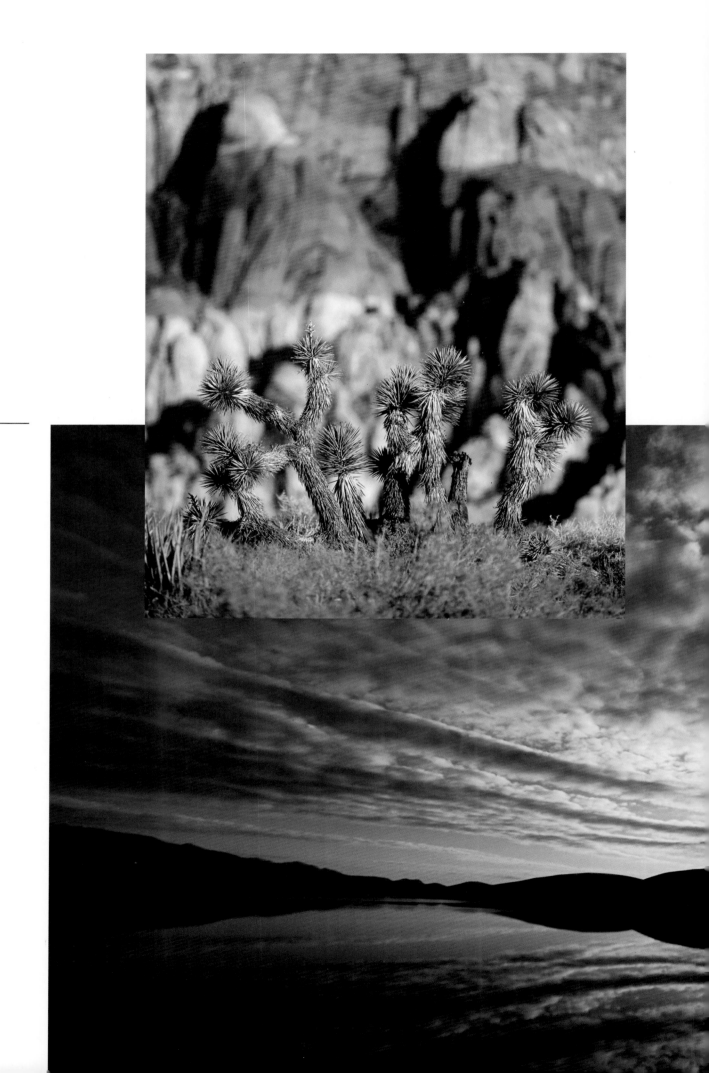

The Joshua tree got its name by suggesting wild-haired warrior of Old Testament. Right: Shifted by wind, patterns of sand change constantly. Below: Though Nevada is mostly arid, watery gems like Topaz Lake are scattered across the state.

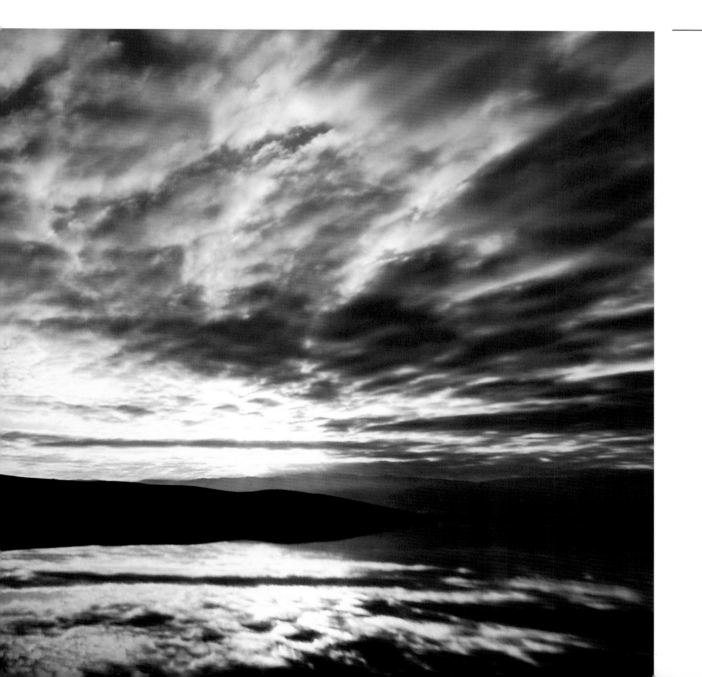

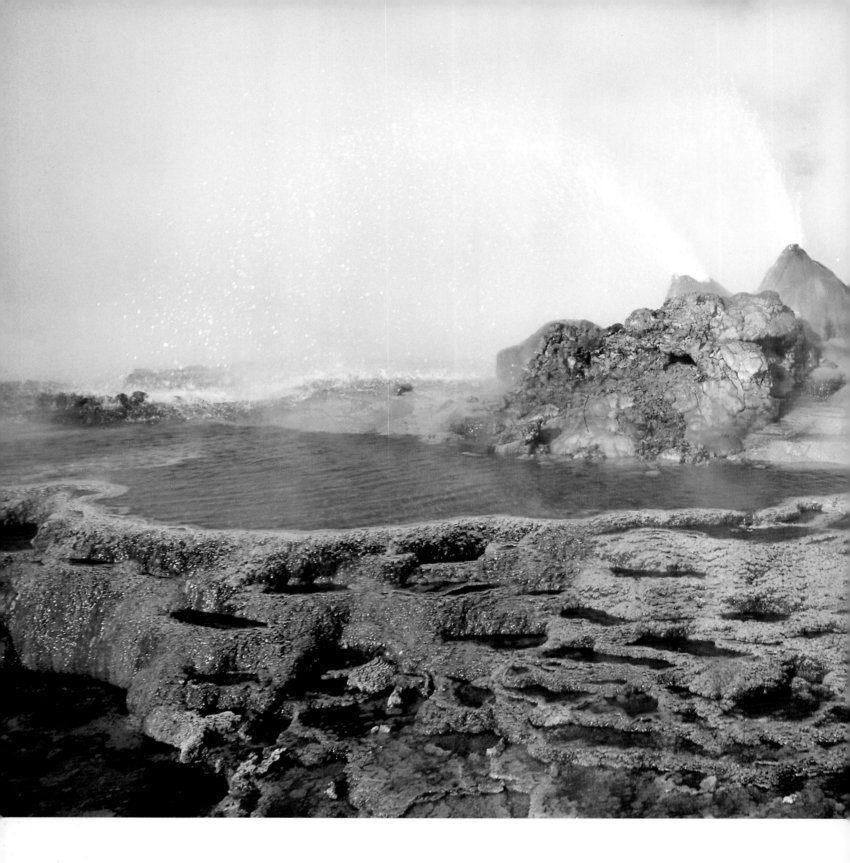

*S*teady plumes of water and steam rise from this geyser in the Black Rock Desert. Right: The Valley of Fire, north of Las Vegas, is a twisted maze of canyons and rock formations. Exploring a side canyon can lead to discoveries around every corner.

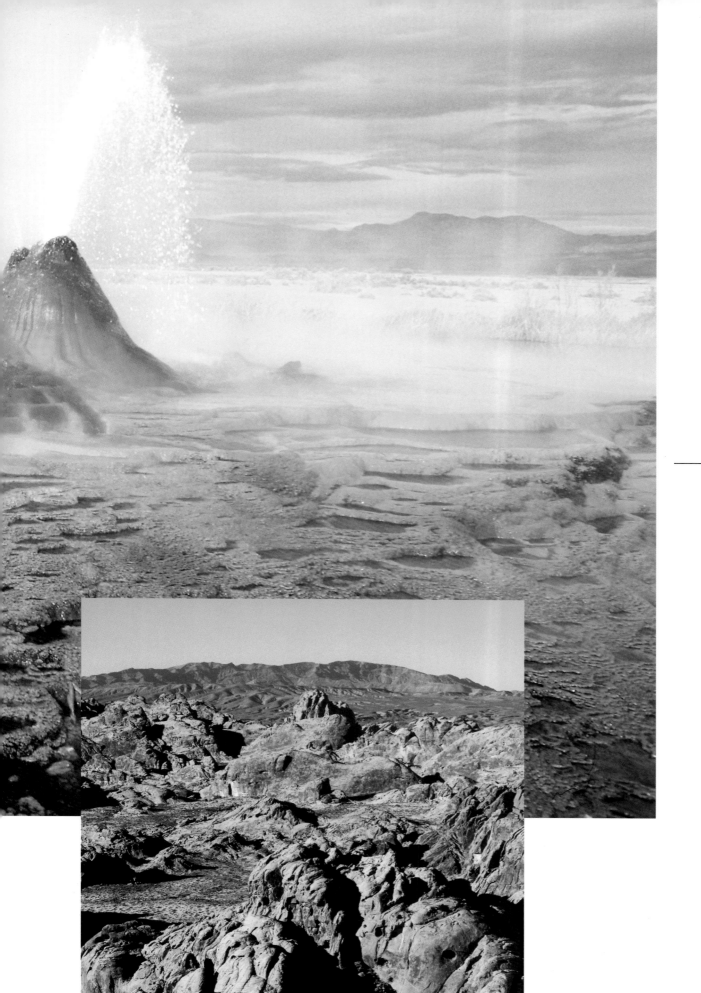

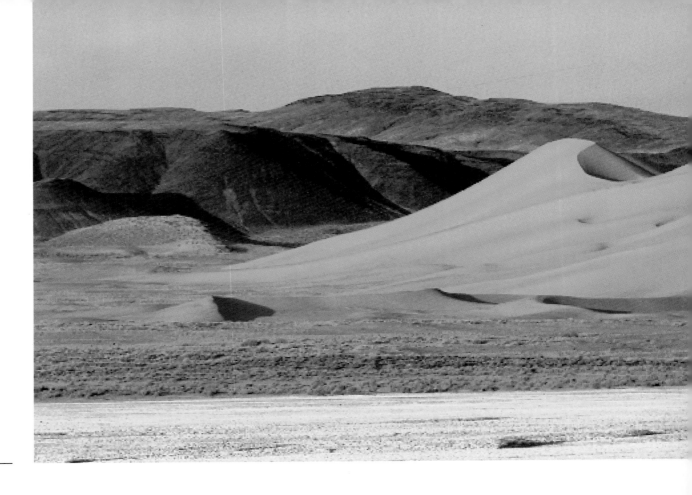

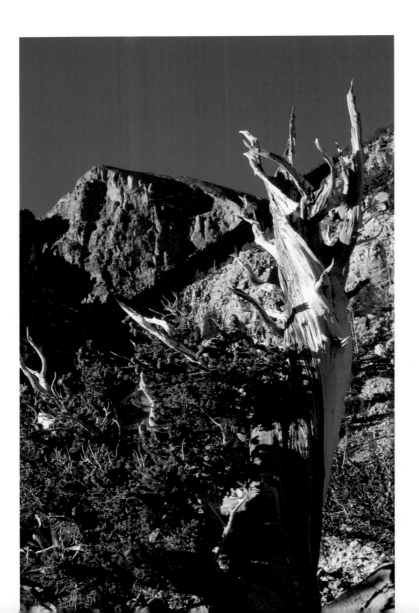

Silent this day, Sand Mountain becomes frenzied arena for off-road vehicles on weekends. Left: Thought to be oldest living things, some bristlecones have survived almost 5,000 years.

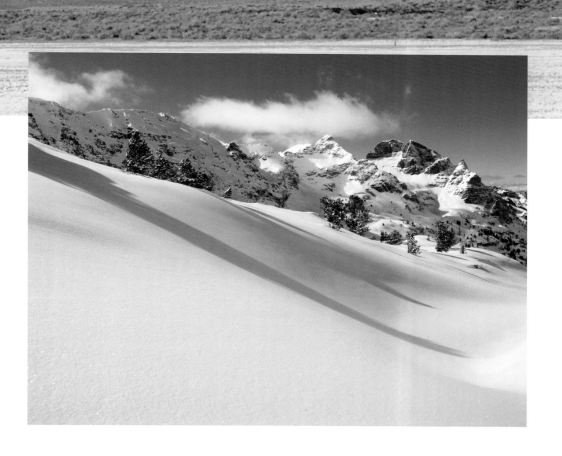

Dunes of a different sort cover
Nevada's high peaks where winter
comes early and stays long.

*S*unset means relief to many animals that must spend summer days underground, in the shade, or in an air-conditioned building.

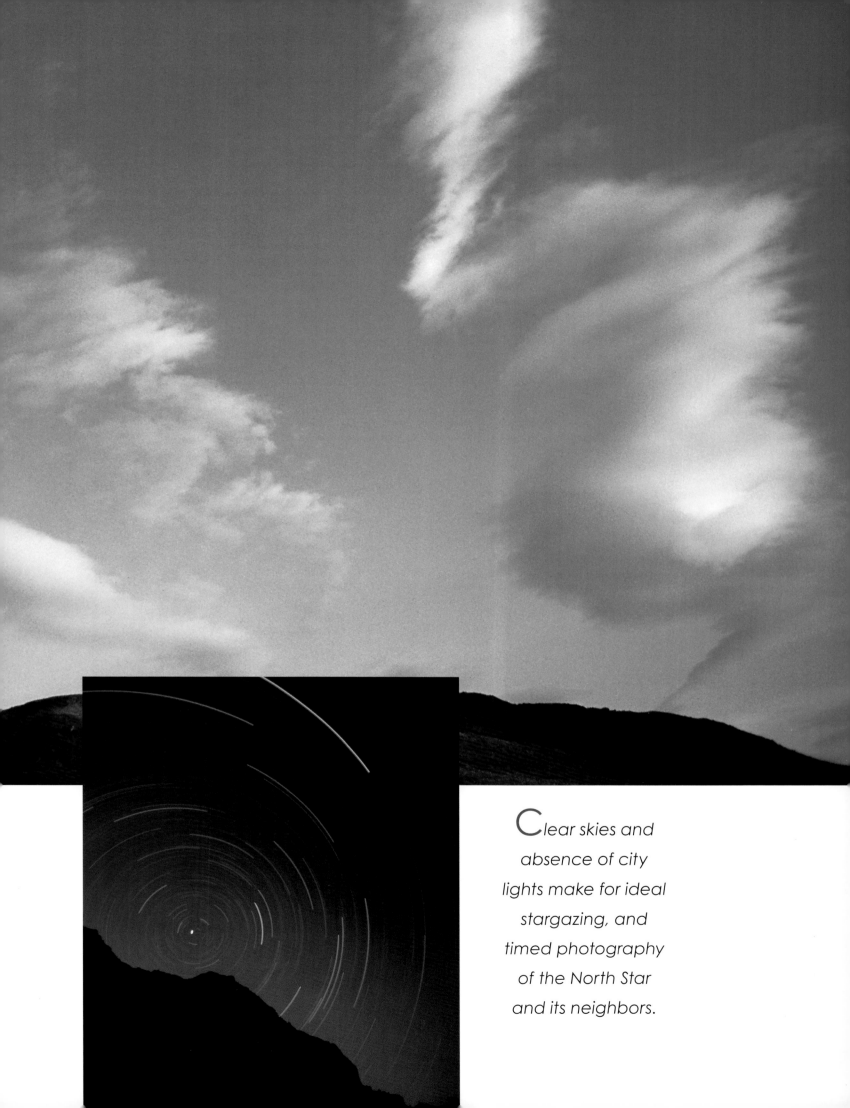

*C*lear skies and
absence of city
lights make for ideal
stargazing, and
timed photography
of the North Star
and its neighbors.

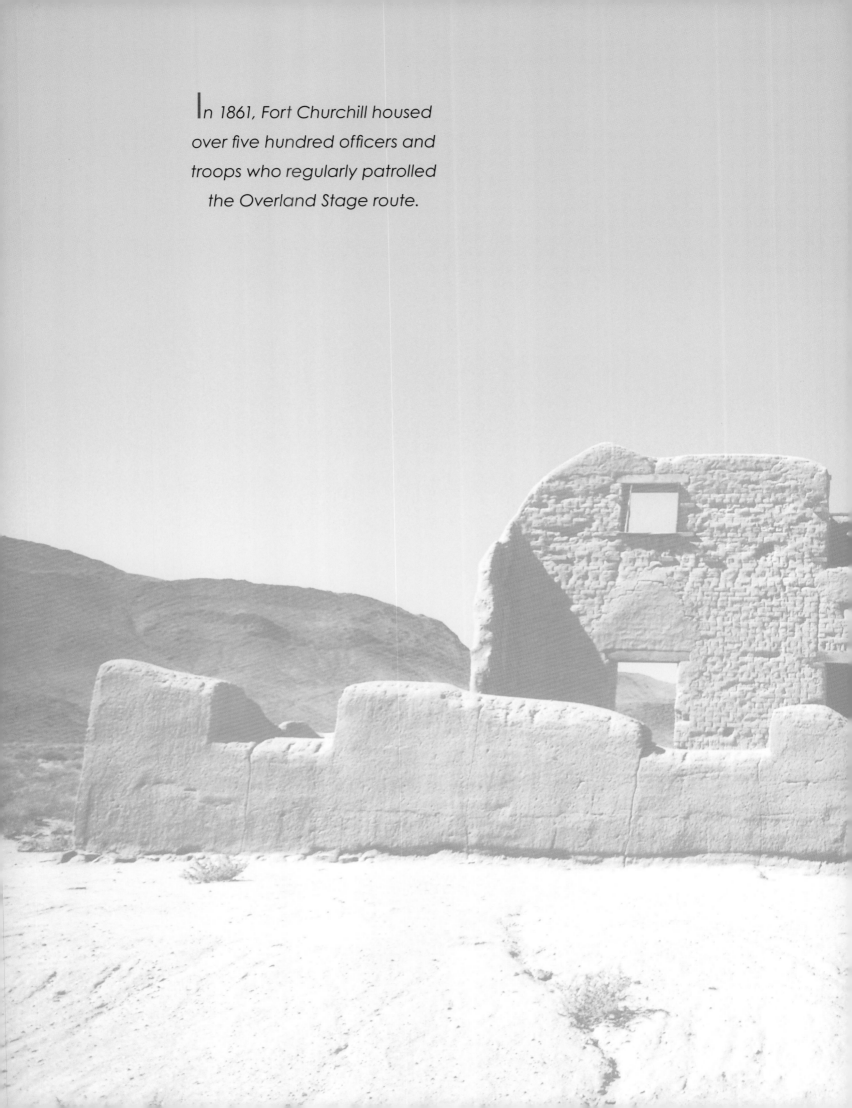

In 1861, Fort Churchill housed over five hundred officers and troops who regularly patrolled the Overland Stage route.

# SEARCHING FOR THE WRAITHS

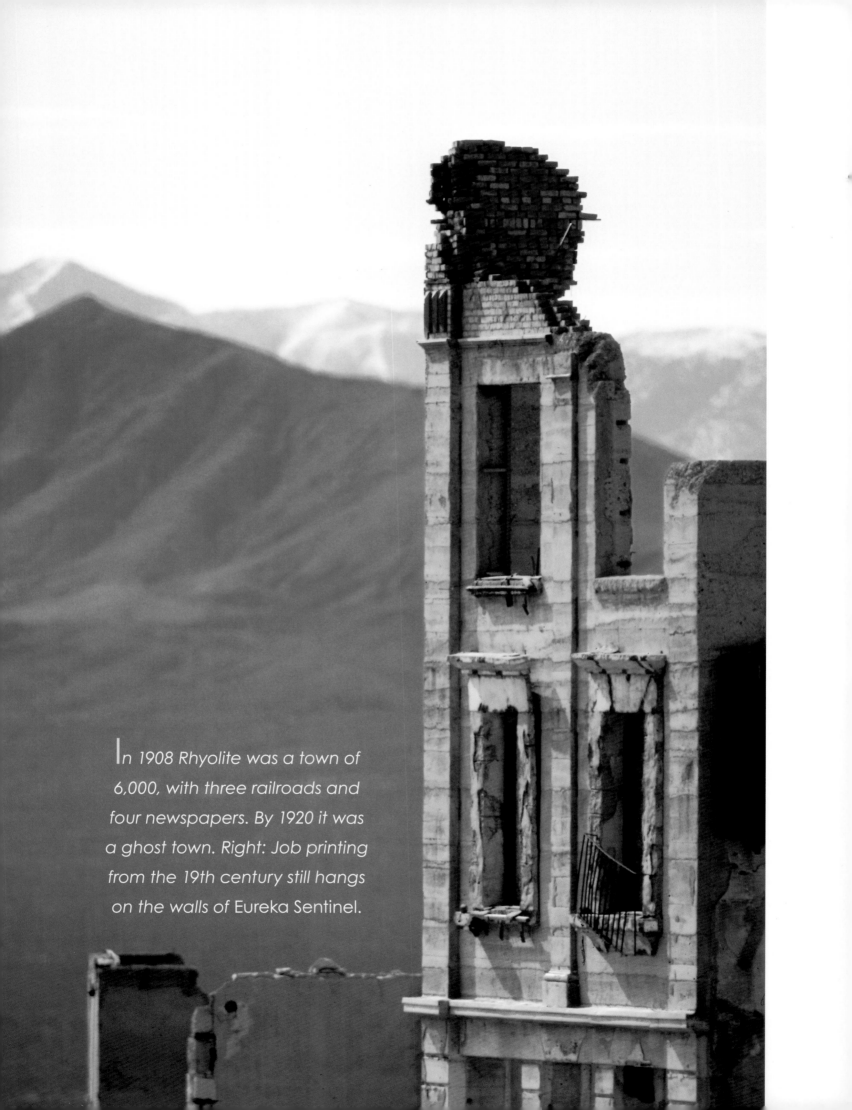

In 1908 Rhyolite was a town of 6,000, with three railroads and four newspapers. By 1920 it was a ghost town. *Right: Job printing from the 19th century still hangs on the walls of Eureka Sentinel.*

"*And then the town died. Just died.*"
—David Toll

Scattered across the Nevada landscape are the remains of dashed hopes and busted dreams. Over the years, a trace of precious metals and the promise of untold riches have spurred more than a few folks to seek their fortunes in the Silver State.

Only a few—the Mackays, Floods, Sharons, Wingfields and a handful of others—ever made much money in mining. But that didn't discourage others from scraping away the sagebrush and chipping away at the rocks at a thousand different places in their quest for gold and silver. Time and again, a bit of color in the rocks would spark a stampede of miners, each drawn by the dream of striking it rich.

Gold Point, Goldfield, Gold Hill, Gold Center, Gold Creek, Gold Bar, Gold Acres, Gold Butte—the names might change a bit but the pattern for every mining town was essentially the same. Gold or some other precious metal would be found. Within a few months, a community would take shape in the shadow of the discovery. Merchants, saloonkeepers, whores, bankers and others would soon follow to provide the services required.

If the ore lasted more than a year, the town might take on more permanence—tent homes and businesses would be replaced by wooden storefronts and cabins. Churches would be built and a newspaper or two might be started up to proclaim to the world the vast potential of the new community.

If more than a few mining discoveries were made in the district, the town might get a few stone and, in later years, concrete buildings. A processing mill might be built to refine the ore—which at this time seemed virtually limitless—being pulled from the ground.

Then, almost as quickly as it started, it would all be gone. The ore would run out. The people would begin to drift away. One by one, the buildings would be abandoned. A town would die and a ghost would be born.

In some cases, such as Virginia City and Tonopah, the town found a way to survive by embracing tourists, replacing mining with some other industry, waiting long enough for mining to come back or by just being too stubborn to die.

Perhaps because of their relative isolation, since many mining towns are tucked in remote crevices of the state, those that survived became sanctuaries for those wanting to escape the structure of what passes for modern civilization. Their reasons for wanting to get away vary: they don't like crowded places, they're a little too eccentric or different; they just want to be left alone; they love the isolation. Every Nevada mining town has its own set of local characters, legends, myths and tall tales. And if you pull up a stool at almost any saloon, you might hear one or two.

## The only game in town

Manhattan is a once prosperous central Nevada mining town that, despite its name, has disintegrated into little more than a main street of crumbling miner's shacks, a few saloons, some creaky headframes, an old wooden church and more rusted cars and abandoned equipment than are found in most wrecking yards. Outside of the town, a modern mining operation—a large open pit—reminds of why the town exists.

There is, in Manhattan, a six-foot by six-foot piece of faded, painted plywood leaning against one of the local bars. A grid, with each square marked with a number, has been painted on one side of the wooden sheet. Three-foot-high chicken wire encloses the sides of the wooden square and the top is open.

Once, while passing through, I stopped at that bar to use the restroom and have a soda. I asked the bartender the purpose of this unusual contraption on the side of his establishment.

"Why that's for the chicken hit contest," he said, passing me a can of pop. "Every summer during Founder's Day, we toss a chicken in there and bet on what number he hits when he craps."

Oh.

## The guardian of Belmont

A few years ago, a Canadian writer asked me to take him on a trip to "the real Nevada." He wanted to see a ghost town and wild horses, and he wanted to meet someone who lived in a ghost town. I said sure, and prayed for rain.

We set out from Tonopah on a cool October morning, driving east on Highway 6, then north on state route 376, before turning northeast on the road to Belmont. We passed no traffic that day, our only companions being a handful of bleached, cotton-swab clouds floating overhead. Not much chance of rain.

The land was wide and open, so much so that the writer remarked that he was working on a book about the Trans-Canadian Highway, of which this reminded him.

"Sometimes, you can see wild horses out around here," I said, eyes expectantly scanning seemingly endless miles of empty, rolling hills. "But probably not today."

Suddenly, as if on cue, a small herd of seven horses, led by a beautiful white stallion, burst from behind one of those hills and began pacing our vehicle about a quarter mile to the north.

"Do you want me to stop so you can get a picture?" I asked.

"No, they'll be gone before I could shoot it. Let's just keep driving. They're very beautiful," he said.

For another several minutes, we watched in silent admiration as those magnificent animals raced across the sagebrush. Then, as quickly as they had appeared, they veered into a hidden creek bed and were gone.

A few minutes later, we arrived at the outskirts of Belmont. We spotted a stout red brick smokestack and decided to investigate. Parking the car, we walked through the sagebrush to the ruins of the Belmont-Monitor Mill.

As we gingerly stepped around and over the scattered chunks of wood and piles of what appeared to be crushed red bricks, I heard a slapping noise overhead. I looked up into the cloudless blue sky and saw a bird passing overhead. I realized the source of the strange sound. It was so peaceful you could hear the sound of a bird's wings hitting the air.

We returned to the car and resumed driving to the center of the old town of Belmont. Ahead, we could see buildings strung alongside the road and, behind them, other structures—some looking like new and others very, very old.

We stopped the car just west of the buildings and, as we climbed out, a man with a thick, gray beard, wearing a red-checked shirt with suspenders holding up a pair of baggy, gray pants, appeared from a small trailer parked nearby.

The towering remains of a former mill site stand over the ghost town of Belmont. Left: Mining core samples lie in disarray in Unionville.

"What are you doing here?" he asked. There was the strong smell of sagebrush about him—as if he'd just rolled in the stuff.

"This is a travel writer and we just wanted to do a little exploring and take a few pictures," I said.

"Well, okay, but just don't touch anything," he said, then disappeared into his trailer. We had met the man I'd heard called the Guardian of Belmont. Other had told me he watched over the premises to scare off bottle hunters and those who would destroy his town.

Careful to respect his wishes, we gingerly walked the main street. A handful of crumbling brick and wooden facades stood on either side of us. Most seemed ready to topple if you so much as used harsh language. Yet there was still a hint of dignity in at least a few of these aged dowagers—an elegance in the graceful brick archways over the former doors and windows of the town bank.

Across the way, the collapsed remains of the Cosmopolitan Saloon—which had survived relatively intact until the mid-1980s—testified to the delicate condition of towns like Belmont. The story goes that some local folks were concerned the old two-story Cosmopolitan might someday fall onto a trailer parked on an adjacent parcel. And so one of the most photographed rel-

*Even a union in Virginia City couldn't save miners' jobs once ore ran out. Right: Paradise grew hay, and quietly survives.*

ics of Nevada's mining past was knocked down. In the windows of the front doors, lying askew on a heap of fallen wood, we could see the torn remnants of curtains.

North of the main street is a large, two-story brick building topped with a boxy, 19th century-style cupola. The Belmont Courthouse—a sign says it was built in 1876 at a cost of $25,000—has survived the ravages of time and vandalism. Standing on a small hill just above the town, the vacant structure still serves to solidly represent the forces of law and order. The courthouse has endured because it was partially restored a few years ago. But, other than the occasional tour by a visiting park ranger, the building is silent until someone can figure out what to do with it.

We circled the ruins in different directions, each shooting photos, entranced by the mood of the place. I thought about the fact that a hundred years ago or so, more than 2,000 people had lived in Belmont. They had left relatively civilized places like San Francisco, Virginia City

and Sacramento and voluntarily come to this remote village tucked in the southern end of the Toquima Range. They had struggled through the desert to this place, struggled to find water, struggled to find food and wood, struggled to dig mines and build homes and a town.

After a time, we both started back to the car. There was a cemetery near the entrance to the town we wanted to visit. I turned the car around and started to head west, away from the main street, when the Guardian once again appeared from his trailer and began waving for me to stop.

"Excuse me," he said, sidling up to the car. "Could you please tell me what time it is?"

"Sure, it's about four o'clock," I answered.

He thanked me and began walking back to his trailer. I began to drive away, when I spotted him in the rearview mirror, again waving me to stop. I backed the car to where he was standing.

"Excuse me," he said. "Could you tell me what day it is?"

So I told him.

### Austin goes the limit

Few mining camps have survived as well and as badly as Austin, Nevada. Located nearly in the geographic center of the state— meaning it's three hours from nearly everything— Austin nearly rivaled Virginia City in affluence and prominence in the mid-19th century.

But the silver ran out—the Spanish have a word, "borrasca," which basically means your mine has crapped out—and the town began to slide into oblivion. A few years ago, Austin appeared on a list of the most endangered historic places in the west. The authors, Randolph Delahanty and E. Andrew McKinney, noted, "Slowly, Austin decays, and with it one of the finest remaining 1860s settlements in the Old West gradually erodes."

Austinites, however, are a feisty bunch and have always been willing to fight for what they want—when they weren't fighting among themselves. A hundred and twenty years ago, when the town needed a church, the congregation passed a hat around and many of the assembled tossed in mining stock certificates. The ample collection was more than enough to build a magnificent church.

A few years ago, when the town's only bank was closed, the folks held a funeral and carried a casket down the main street. When the long-abandoned but still proud St. Augustine's Catholic Church was threatened with collapse because pigeons had nested in the belfry for decades and filled it with tons of guano, a judge sentenced the town drunk, on the occasion of his umpteenth infraction, to shovel out the massive accumulation.

It is only fitting that Austin was also the home of the Sazerac Lying Club, a mythical organization devoted to the art of prevarication—and that the club's very existence was itself a magnificent lie.

The Sazerac Lying Club was the invention of a bored newspaper editor on a slow day. In 1873, Fred Hart of Austin's *Reese River Reveille*, found himself with a blank hole in the paper and no news. Desperate for copy, Hart concocted a story about the formation of a new club, the Sazerac Lying Club, and election of its officers.

While there was an Austin saloon named the Sazerac, and its regulars frequently indulged in the blowhard hyperbole created from too many spirits, the club was pure fantasy on Hart's part.

Reaction to the short article was favorable and Hart began to feature additional tall tales, allegedly told at the nightly sessions of the club. Many were picked up by other frontier newspapers, and word of the famous lying club began to spread.

Alas, in 1877 Hart decided to close down the club, writing a humorous final piece about its final session. Shortly after, Hart departed

Austin for Virginia City, where he worked at the famed *Territorial Enterprise* (former home of Mark Twain) and, later, in San Francisco.

Austin has always attracted strange characters. One of the town's founding fathers was Reuel Colt Gridley, a grocer and sometime political activist. In 1864, Gridley bet that if his candidate for mayor didn't win, he would carry a 50-pound sack of flour the length of the town, roughly a mile and a quarter uphill.

He lost and, good to his word, lugged the sack up the main street, which was lined with supportive citizens. After his trek, he decided to auction the now-famous sack of flour to the crowd, with the proceeds going to the Sanitary Fund, a precursor to the Red Cross.

The winning bidder donated the sack back to Gridley, who auctioned it several more times during the day. By evening, he had raised more than $4,000 in cash (plus several thousand dollars in property deeds) for the fund.

The story of Gridley's sack of flour spread and he was invited to conduct similar auctions in other towns throughout the country. During the next year, he would raise between $100,000 and $300,000 (estimates vary) for the Sanitary Fund.

Unfortunately, as a result of his long absences from his store, and the fact his partners had pulled out of the business, when he returned to Austin, he found himself heavily in debt.

He was forced to sell the store. Also in ill health, on the advice of his doctor he moved to California, where he died in 1870. Gridley would most likely have been forgotten—he didn't even merit an obituary in Austin's *Reese River Reveille* when he died—if Mark Twain hadn't immortalized the grocer and his sack of flour in *Roughing It*.

Today, the famed sack of flour is on display at the Nevada Historical Society in Reno.

Another of Austin's leading citizens was Anson P. Stokes, an eastern investor who had made millions in railroads and mining. In 1896, Stokes decided to build a summer home for his sons, who were supervising his holdings in the district. He chose to build the home just south of Austin on a hillside overlooking the vast Reese River Valley.

But Stokes didn't build anything ordinary. He erected a three-story, stone structure, the design of which was based on a medieval tower he'd seen and admired near Rome.

*More than a century ago, the discovery of silver made Austin Nevada's second largest town. The train station in Gold Hill (facing page), near the original discovery site of the Comstock Lode.*

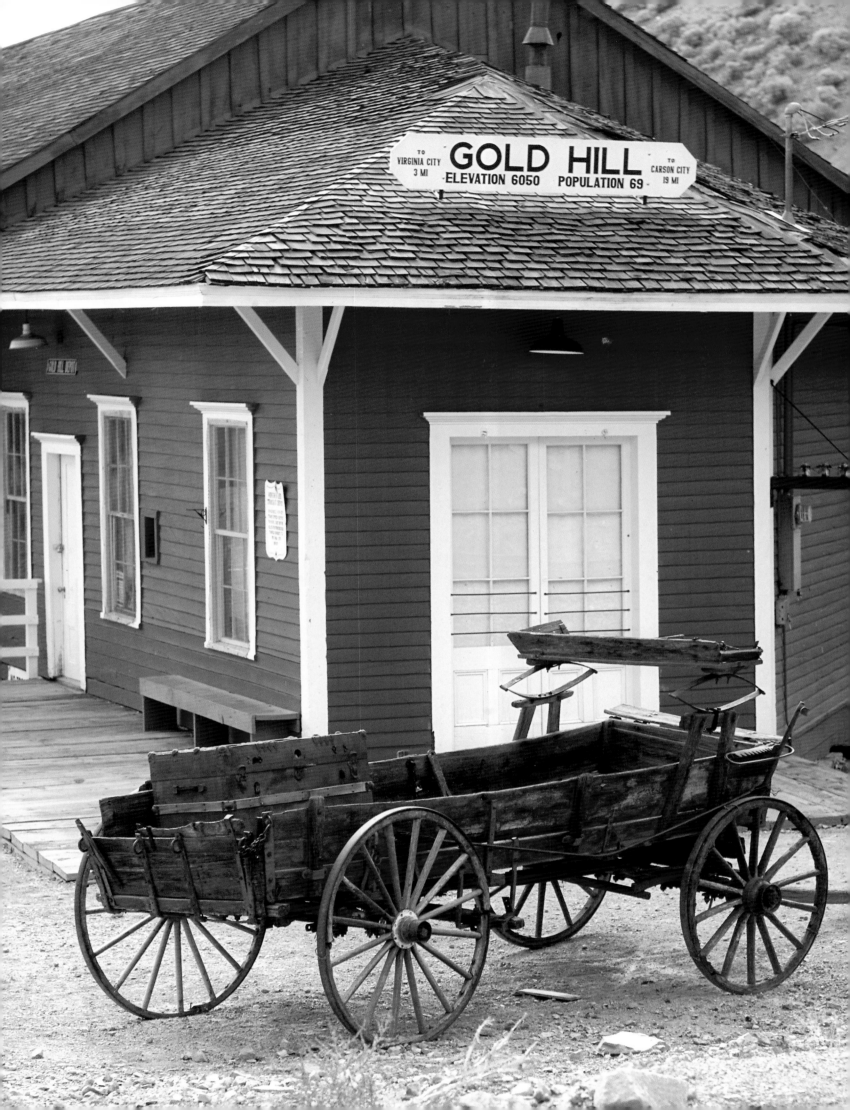

Built of native rock and clay mortar, the tower—which became known as "Stokes Castle"—boasted three floors, each with a fireplace, wooden balconies on the two upper floors, indoor plumbing and a battlemented terrace on the roof.

The castle was inhabited for only a few months in the summer of 1897, then was abandoned. After all, Austin's ghosts needed a place to live.

### Eureka's snail mail

Just down the road from Austin is the mining town of Eureka. While never quite as rambunctious as its neighbor, Eureka has its own tales to tell.

For instance, a few years ago, the water line in the old Masonic Building burst. A plumber was called and, after turning off the water in the historic 1870s building, he began tapping the pipe, through the basement walls, to determine the location of the break.

*Eureka's Masonic building has a checkered past, as a former post office whose mail went undelivered for more than a century.*

He followed the pipe to the corner of one room, but, to his surprise, there was no door leading into what had to be an adjacent room. Rather, a short hallway led from the first room to the temple chambers, about ten feet farther, but with no access to the apparent small room in between.

To fix the pipe, the plumber decided he had to punch through the wall. Once inside, he found a small, square room, the ceiling of which was all the way at the top of the building—like a narrow, two-story empty shaft.

As he stumbled about in the dark, he also felt piles of papers beneath his feet. Perplexed, he collected the papers and brought them out into the light. Upon inspection, he saw they were dozens of letters, packages and newspapers, all with cancelled postage stamps dating to the 1870s.

The plumber had inadvertently stumbled onto a treasure trove of rare 19th century Eureka mail. Apparently, the upstairs portion of the Masonic Building had once served as the town's post office. Since mining town residents were extremely transient, the Eureka post office had discovered the unused two-story shaft, which they could access from a slot in the wall, made a perfect "dead letter" file for undeliverable mail. There it sat for more than a century.

An interesting postscript is that in addition to leaky pipes, the aging Masonic Building needed a new roof. The Masons found a Reno

*Domestic burros like these helped explore Nevada, were released when no longer needed. Descendants thrive in the wild.*

stamp collector willing to help them sell their discovery and raised enough money to put a new roof on the building and, presumably, fix the leak.

## Comstock time

Anyone who has ever done business with someone from Virginia City learns about "Comstock Time." Your watch and calendar may tell you one thing, but in Virginia City most everyone is on Comstock Time. This strange, mysterious and wonderous thing allows carpenters to finish their work on time, no matter when it's done, newspapers to be published on time, regardless of how irregular their schedule, and shops to be open during regular business hours, whether that's true or not.

Comstock Time isn't so much a measurement of hours, minutes, or seconds. Rather, it's a state of mind that allows one to accept the notion that the conventional view of time is irrelevant and that things will happen in their own good time.

For years, the best way to measure Comstock Time was to check it by the old Victorian clock in front of the Virginia City post office on C Street. On one side of the clock, the time is accurate. But on the other side, the hands of the clock have been removed.

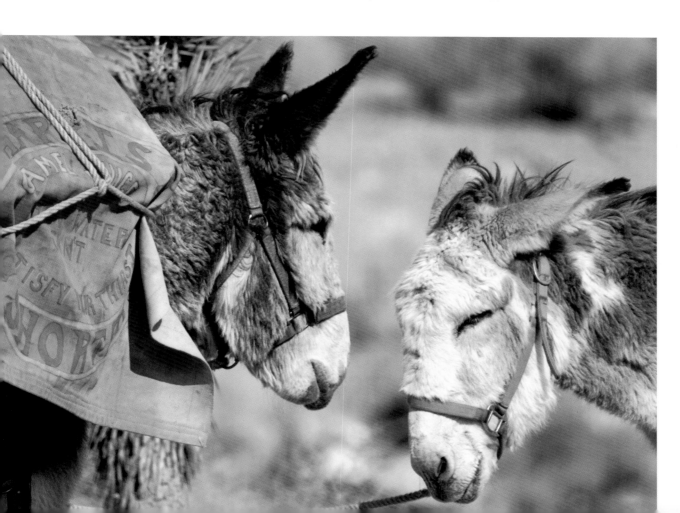

The vast territory we now call
Nevada was one of the toughest
obstacles for pioneers who crossed
it in covered wagons.

# THE PAST

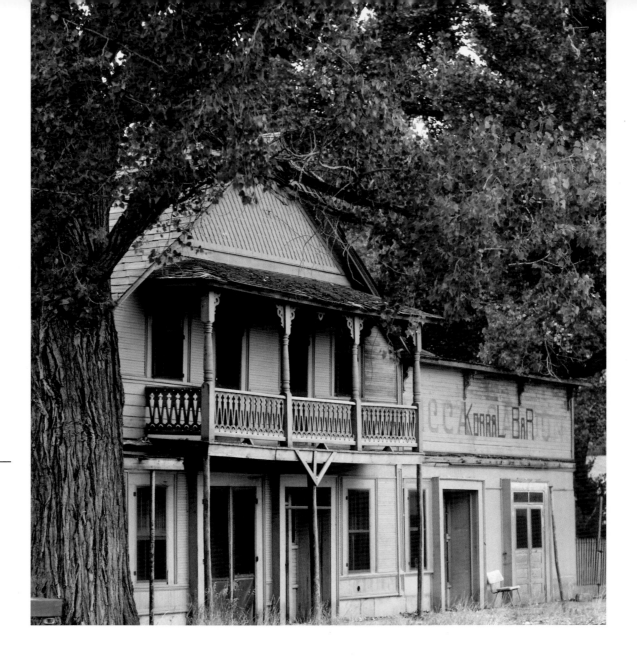

What memories linger in an old building
such as this one in Paradise?

Celebrating the past with
a parade in Rhyolite.

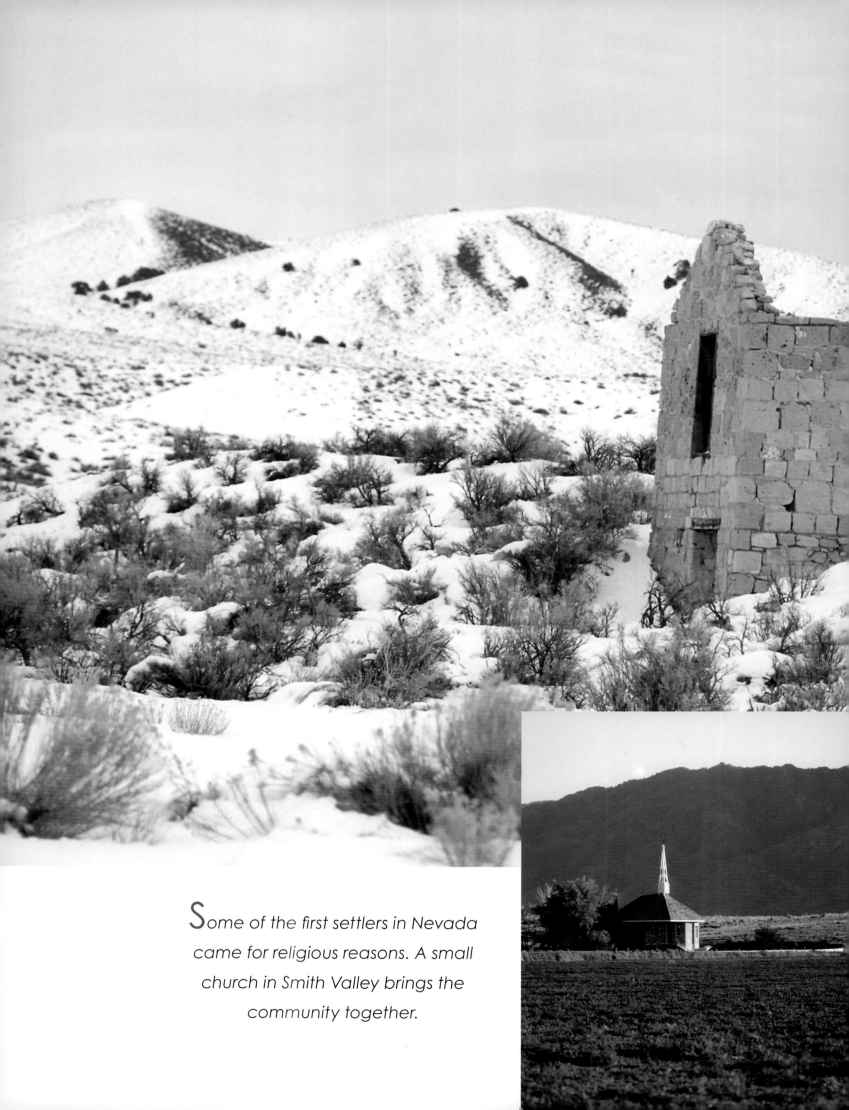

*S*ome of the first settlers in Nevada came for religious reasons. A small church in Smith Valley brings the community together.

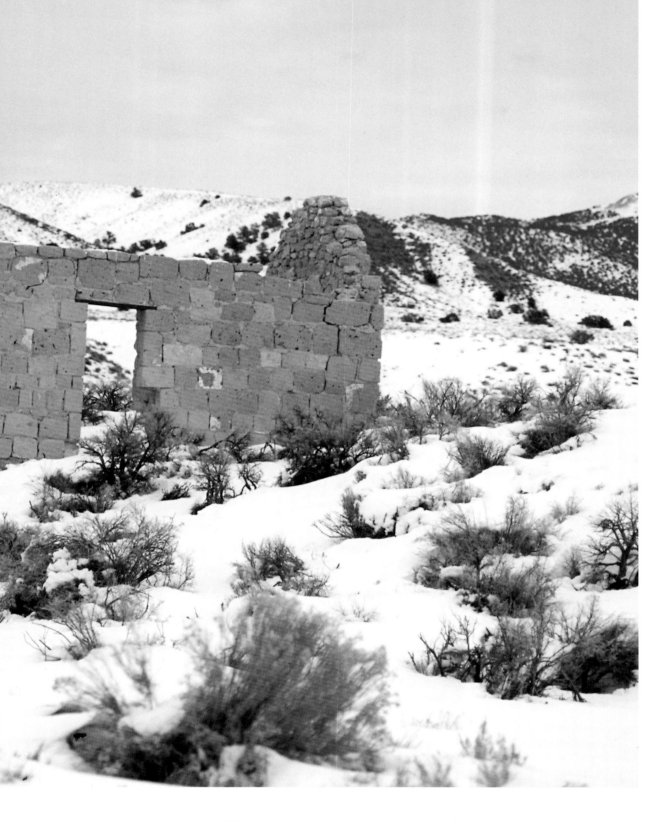

The "boom and bust" mining lifestyle plays on today. Ruins of homes like this one in Palmetto attest to a more lively past.

*The former mining town of Jarbidge has shrunk to a handful of permanent residents. Below: A roadside reminder of Wellington's past.*

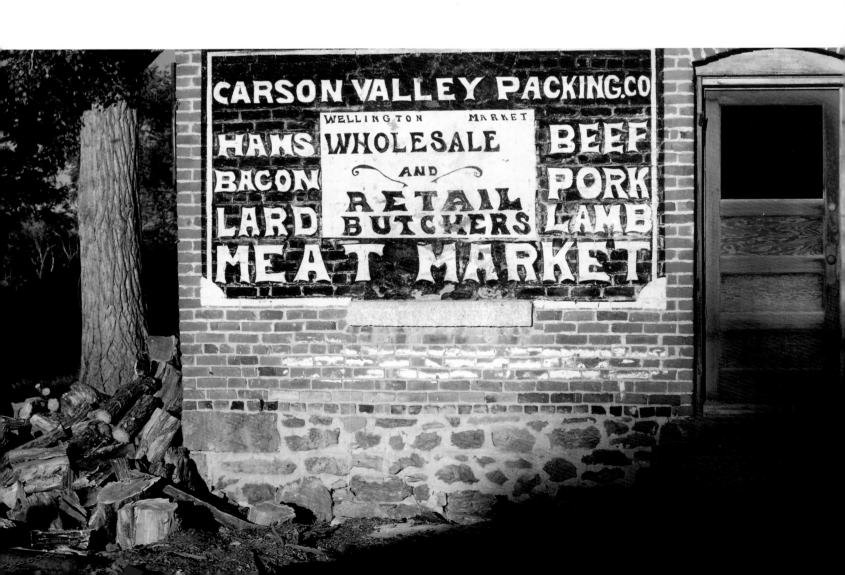

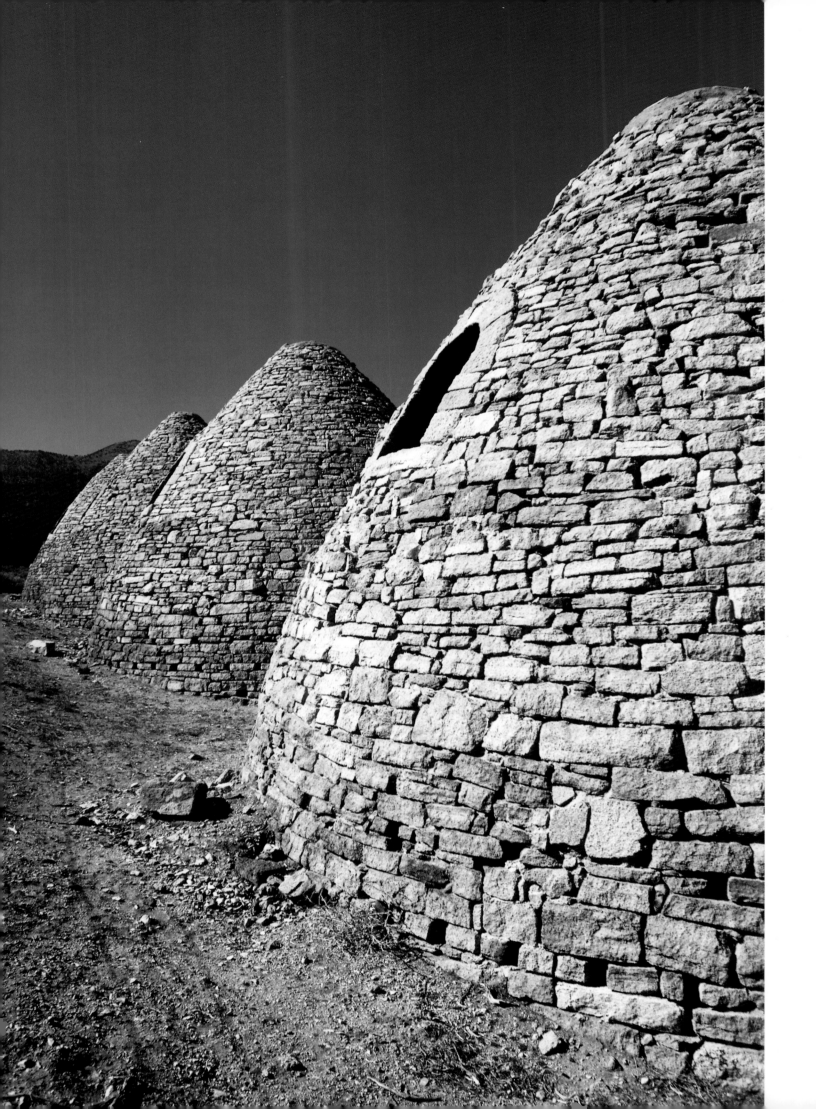

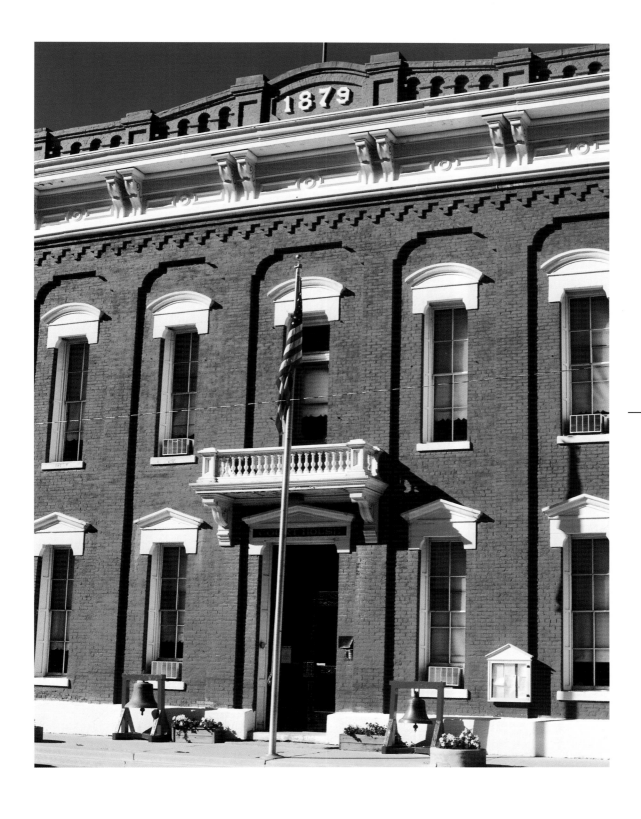

The Eureka County courthouse
stands fully restored to its original 1879
condition. Left: The Ward Charcoal
Ovens were once stacked with piñon
pine to fuel the Martin White Smelter.

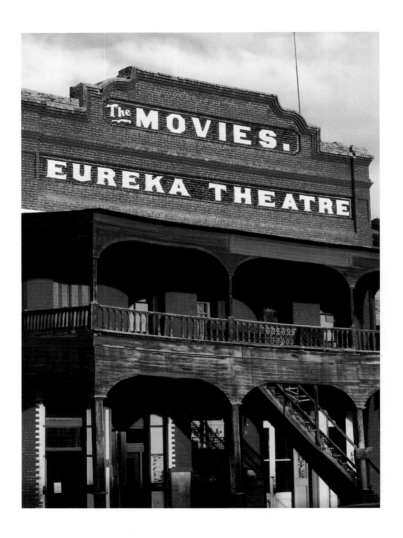

The Eureka Theatre brought
a look at the outside world
to an entertainment-starved
community. Right: Discarded
bottles become collectors' items
as time passes in Goldfield.

*The men who worked the mines had harsh and often short lives. Below: A house built of bottles is one of the few buildings still standing in Rhyolite today.*

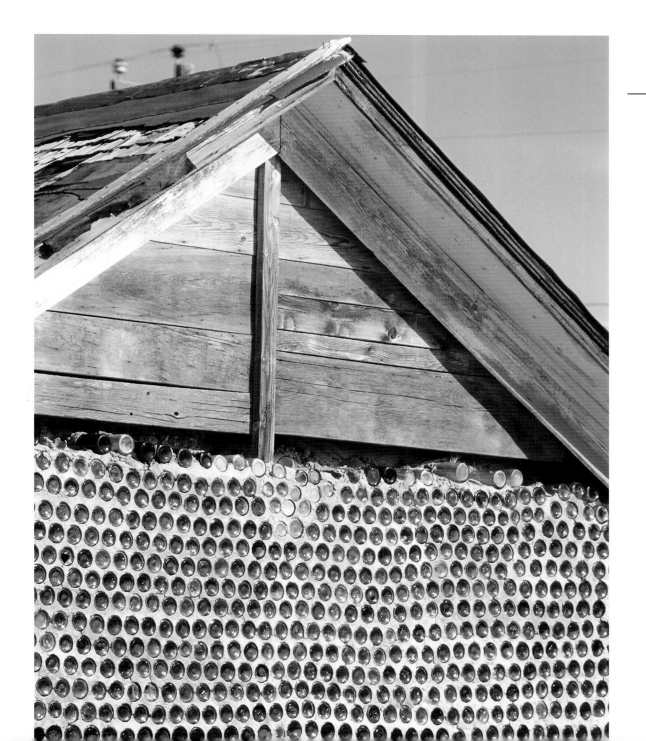

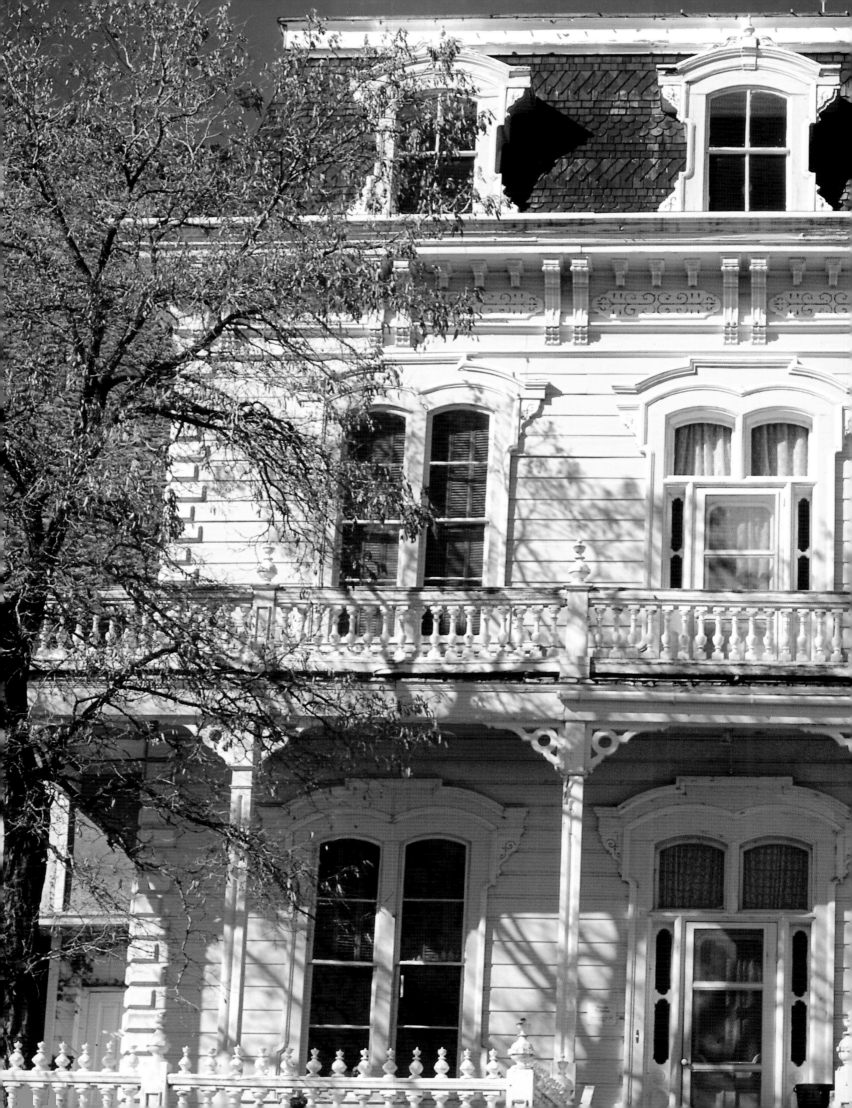

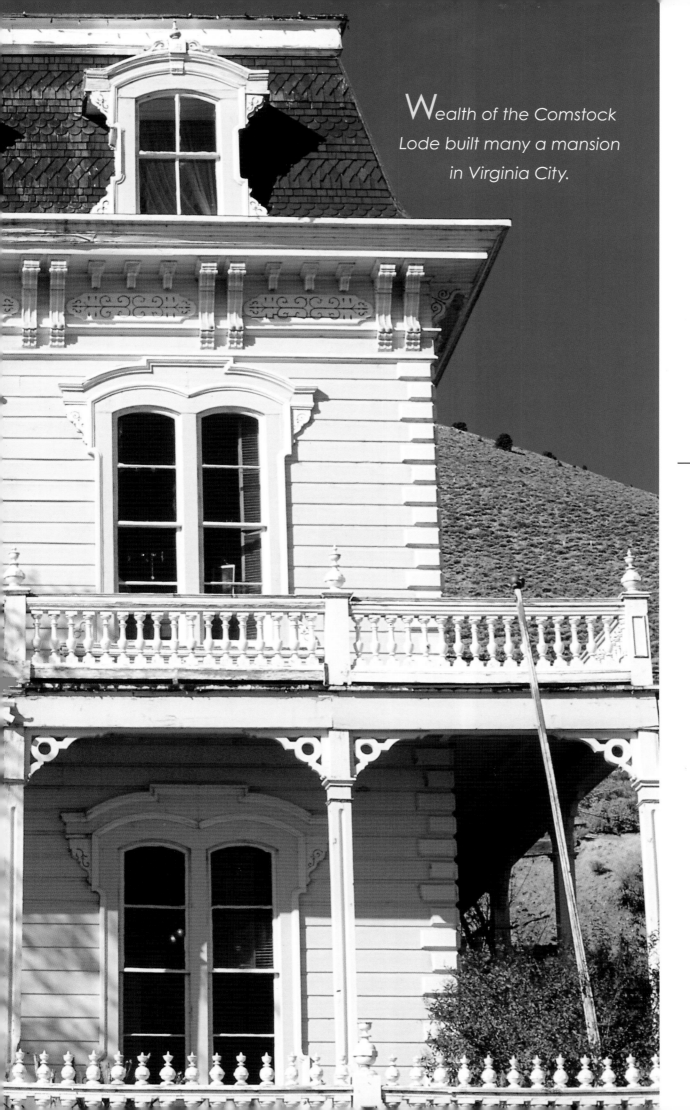

*Wealth of the Comstock Lode built many a mansion in Virginia City.*

$\mathsf{R}$ailroads played a key roll in the emergence of small towns all across the state. A newly restored engine, from the famous Virginia & Truckee Railroad, finds a home in the Railroad Museum in Carson City.

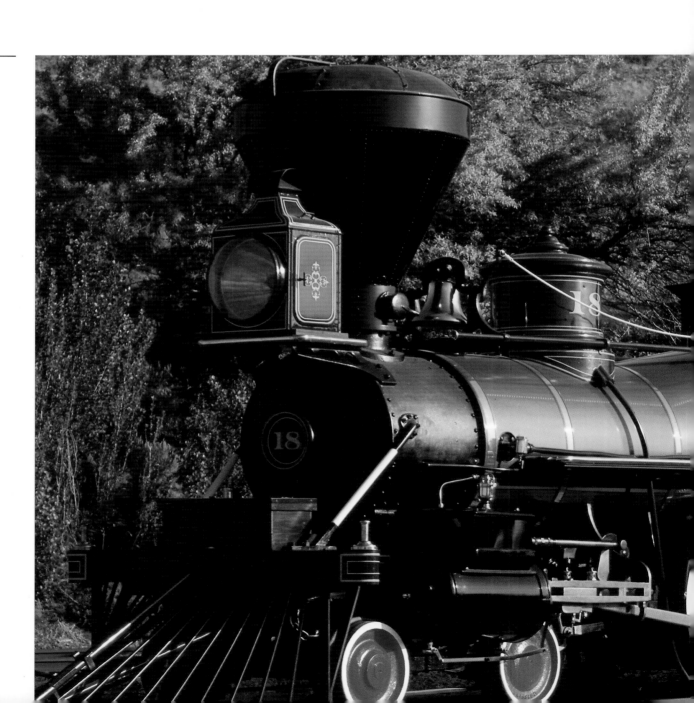

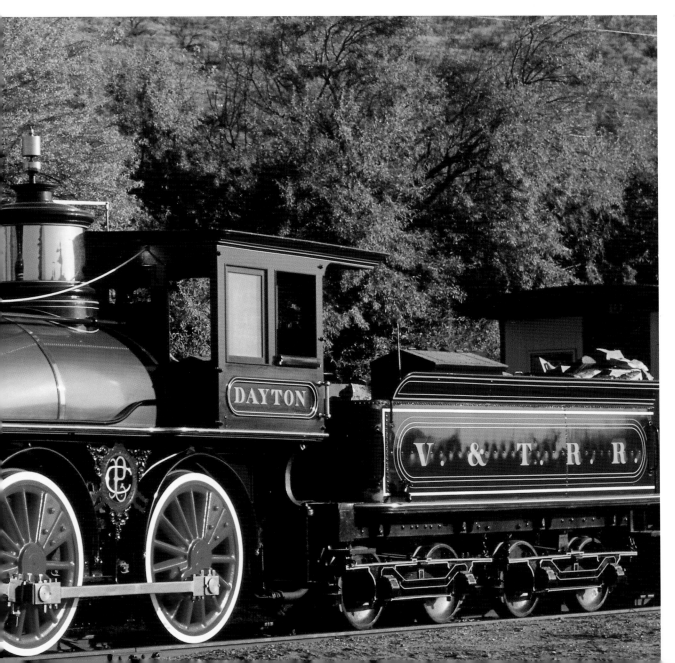

Looking down from Genoa Peak
on the Carson Valley, where much
of state's beef is raised. Right:
Genoa Saloon is state's oldest.

# MEALTIME

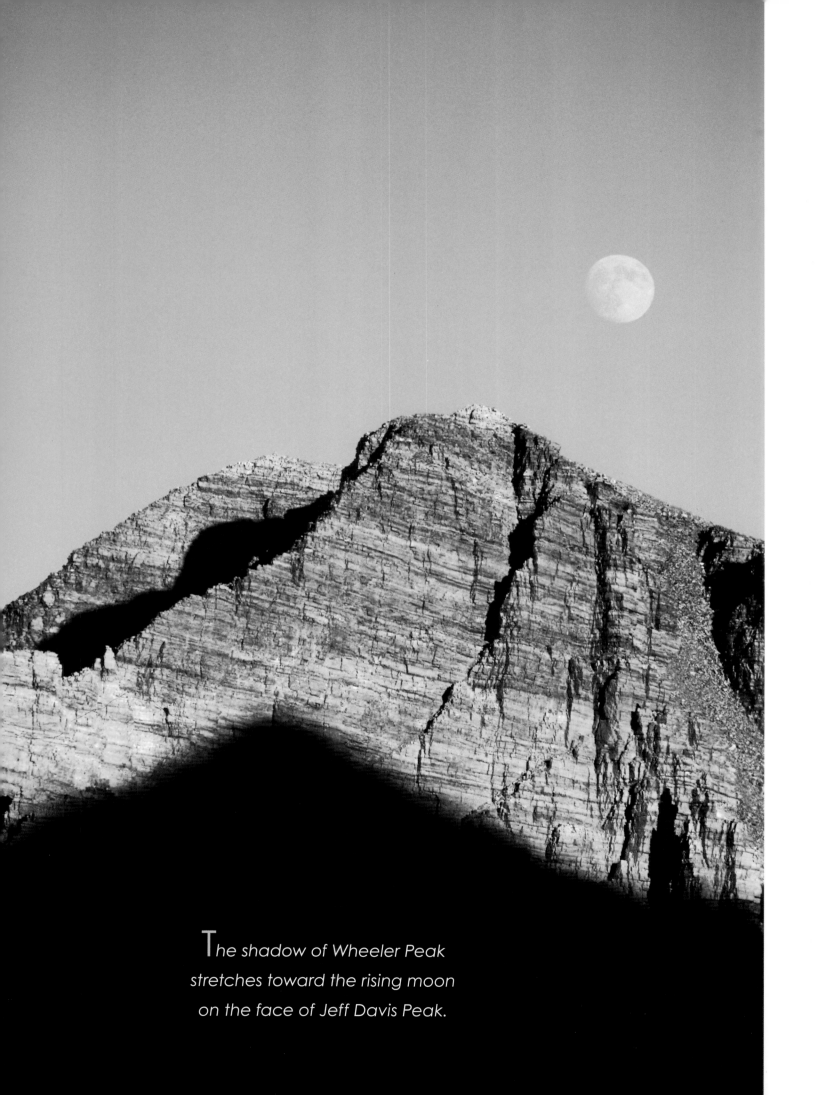

*The shadow of Wheeler Peak stretches toward the rising moon on the face of Jeff Davis Peak.*

*" A public establishment masking*
*many private intimacies. "*
*—William A. Douglass*

You can never eat alone at a Basque hotel. One of the unique aspects about dining at one of the dozen or so authentic Basque boarding houses found in Nevada is that the meals typically are served in an intimate, family style. You sit down at a long table, usually covered with a red-and-white-checked tablecloth, and are proffered food while sitting with a bunch of strangers. You can find yourself seated adjacent to anyone from a visiting mining engineer to a local insurance salesman.

The Basque hotel developed in the late 19th century to offer a home away from home for the many Basques brought to the American West to tend the growing flocks of sheep appearing on the open range.

Basques come from an area in southwestern Europe that encompasses the crest of the Pyrenees mountains and part of the coast of the Bay of Biscay; it straddles the border of modern France and Spain. Basques speak a unique language, unrelated to other European tongues, and, it has been said, have never been truly tamed by any monarch or country.

The first Basques arrived in Nevada in the 1890s, during a time when the state's vital mining industry had begun to wane and agriculture was becoming more important. A common myth is that the Basques coming to the West were already professional sheepherders. Anthropologist William A. Douglass, who has studied Basques in the West, notes that, contrary to that image, most were merely poor, relatively uneducated and rural. While their rural background provided them with skills in handling livestock, they were generally successful because they were ambitious and worked hard under extremely difficult conditions.

The sheepherder had little social status. In the American West, sheep were considered far less noble than cattle. To be a sheepherder was to be doing something beneath the dignity of most—which made it a job usually reserved for foreign immigrants, like Basques.

On the other hand, it was perfect work for a newly-arrived Basque. He didn't need a formal education, didn't have to know English and, if he worked hard, could make enough money in a couple of years to purchase his own sheep and expand his horizons. Within a short time, the sheepherder might be able to bring a relative or friend from his Basque homeland, and the latter would repeat the pattern.

The work was demanding and lonely, requiring the sheepherder to spend months in the most remote parts of Nevada, without much companionship. As a result of such conditions, it was almost impossible for most Basques to learn the language and assimilate into American society as did members of most other immigrant groups. Obviously, opportunities for establishing a family were also extremely limited.

Most Basques looked upon their American experience as little more than an opportunity to escape poverty at home, then make enough money to return there to buy a farm or other business (the Basques called these returnees, "Amerikanoak.") Because of the difficulties of assimilating, and the attitude that a couple of years in Nevada was a temporary assignment, Basques retained a strong sense of cultural identity.

All of these factors helped create the Basque hotel. Not every Basque immigrant returned to the Pyrenees. Some sent for wives and family and chose to establish businesses in America, including small hotels and boarding houses. These became the focus of Basque culture in a community. Sheep men, down from the hills, would flock to the hotels for warm meals, soft beds and opportunities to catch up on news from home, read Basque newspapers and speak in their native tongue.

By the beginning of this century, Basque boarding houses had cropped up in a number of Nevada communities, including Winnemucca, Elko, Reno, Ely, Carson City and Gardnerville. Of course, they didn't cater only to Basques but encouraged business from anyone seeking a bed for the night and a good, hot meal.

### Free refills

A few years ago, I decided to have dinner at the Ely Hotel, a small Basque boarding house and restaurant that used to be in the center of the former copper mining town of Ely. I was early and the owner hadn't yet set up for dinner, so I sat at the bar to wait and ordered a Picon punch. Now, a Picon punch is powerful drink. A bartender will tell you it's made of a European liqueur named "Amer Picon" (a bittersweet orange cordial unrelated to the pecan) mixed with grenadine, often fortified with brandy. One Picon punch will make you late for dinner. Two will have you arguing with the bartender about the unification of Europe and after three, you'll be singing the Basque national anthem while cursing the memory of Franco.

No one has ever walked away hungry from a Basque meal. In addition to seemingly endless courses, the meals include as much of any particular dish as you wish to eat. Specific types and flavors of food may vary, but at a typical Basque restaurant, they'll start you off with a basket of fresh French bread and butter, followed by a tureen of soup, followed by a large bowl of salad, followed by a plate of spaghetti or vermicelli or some other pasta, followed by a bucket of beans,

followed by platters of French fries, followed by another side dish, usually with vegetables, followed by the main dish, generally a huge slab of marinated and broiled beef or lamb steak. After that feast, some restaurants will bring you sliced apples and cheese and ask if you'd like a bowl of ice cream. At some point in the meal, the waitress or waiter will also bring you a carafe of hearty red wine. Obviously, the secret is to pace yourself.

Sometimes, it's best not to know what you're being fed. Basque cuisine varies as a result of provincial differences (e.g., coastal Basques serve more fish while mountain folks tend toward beef and lamb). Naturally, in Nevada, the Basques have adapted to their surroundings . Therefore they serve not only a lot of

*If you plan to eat dinner at a place resembling this one, skip lunch.*

beef, pork and lamb dishes but also rabbit, trout and a subcategory I call "entrail food." The latter include such delicacies as sweetbreads (animal pancreas), tongue and "mountain oysters" (bull or sheep testes).

Of course, you never know who you will sit next to during one of these Basque culinary overloads. Once, in Ely, I found myself next to three visiting oil engineers who had been testing an area for oil reserves. Their talk of sonic thumpers and other electronic wizardry turned out to be far more interesting than the day-old newspaper (the only kind you can get out there) I'd planned to read.

But I left after they'd finished their third Picon punch and were beginning to sing.

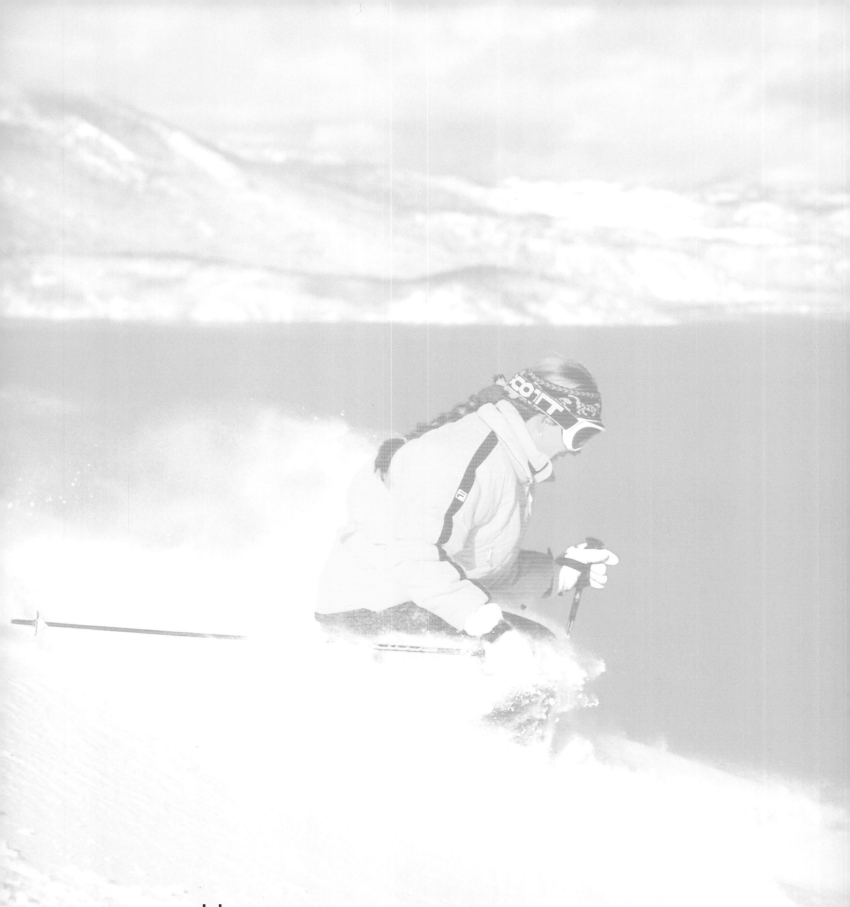

Heavenly skiing draws thousands of people to the slope around Lake Tahoe's deep blue waters. Inset: The deep blue is burnished to gold just for a magical moment.

# THE PEOPLE

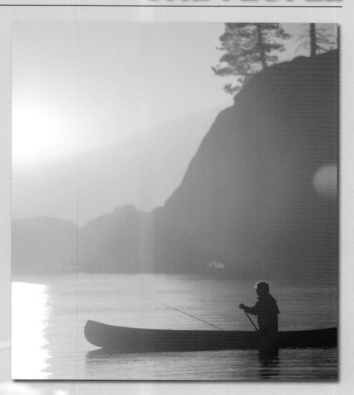

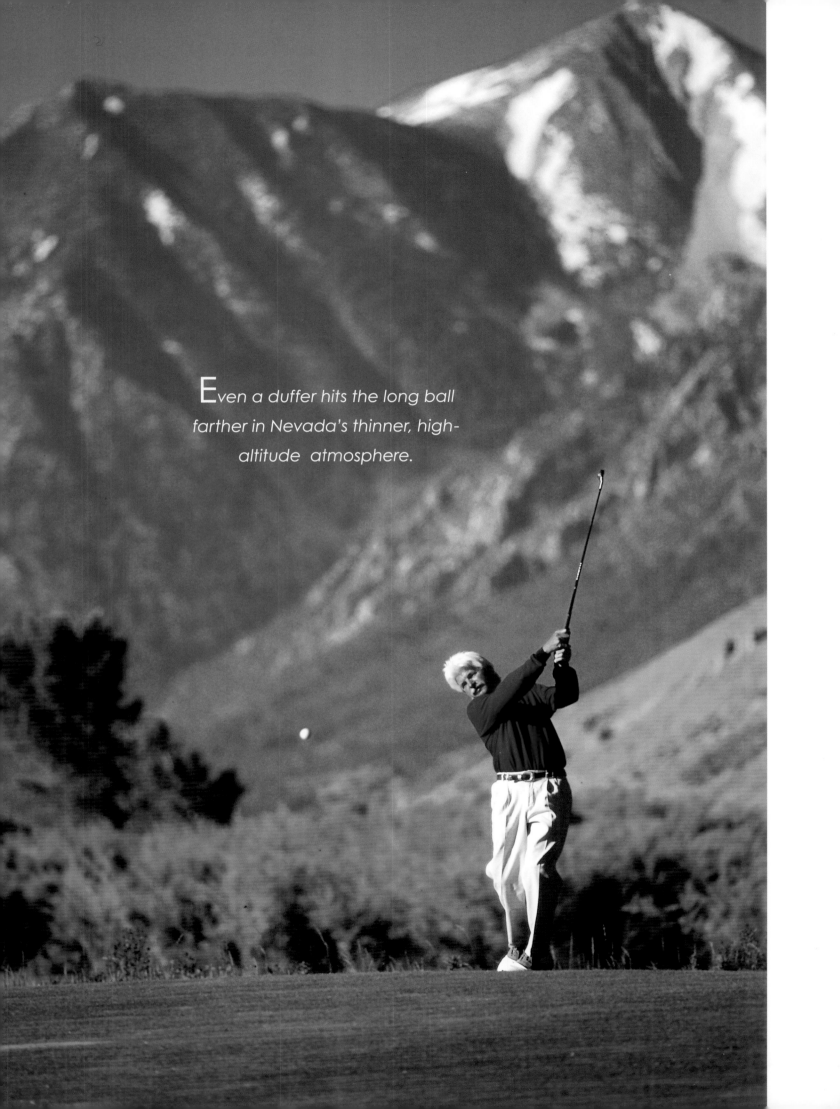

Even a duffer hits the long ball farther in Nevada's thinner, high-altitude atmosphere.

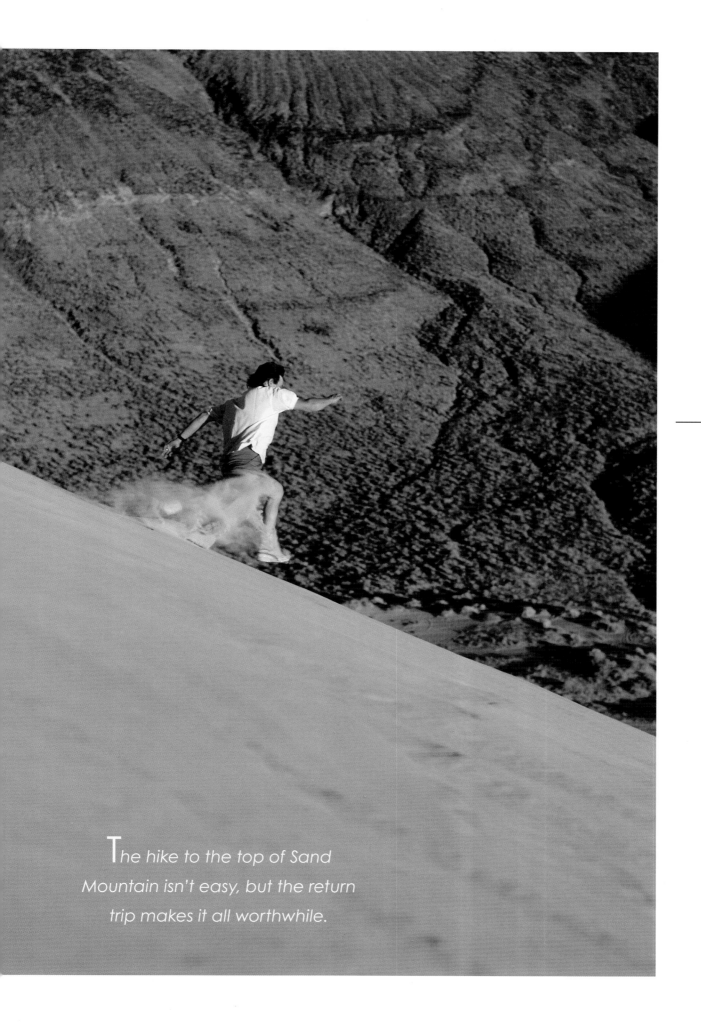

The hike to the top of Sand Mountain isn't easy, but the return trip makes it all worthwhile.

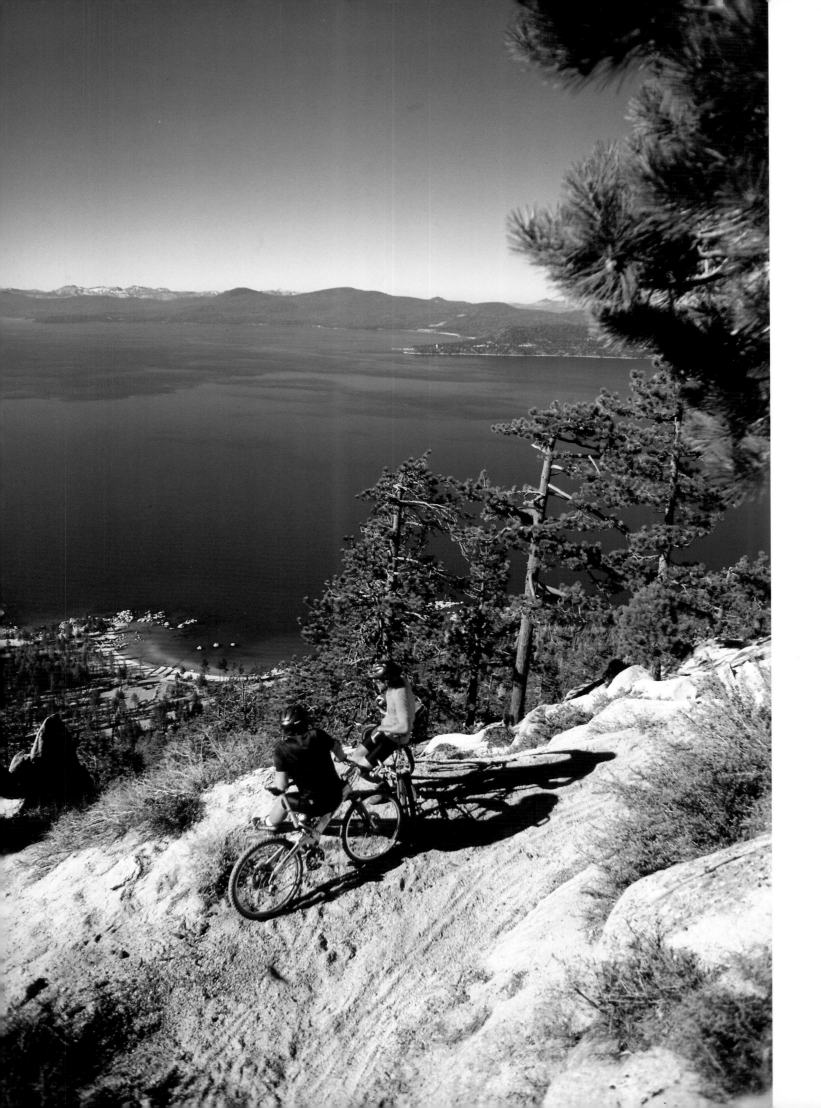

*Pausing for a break and enjoying the view, mountain bikers have miles of trails to explore around Lake Tahoe. Below: Floating on a raft in Lake Tahoe takes on a whole new sensation when you see the bottom so far below.*

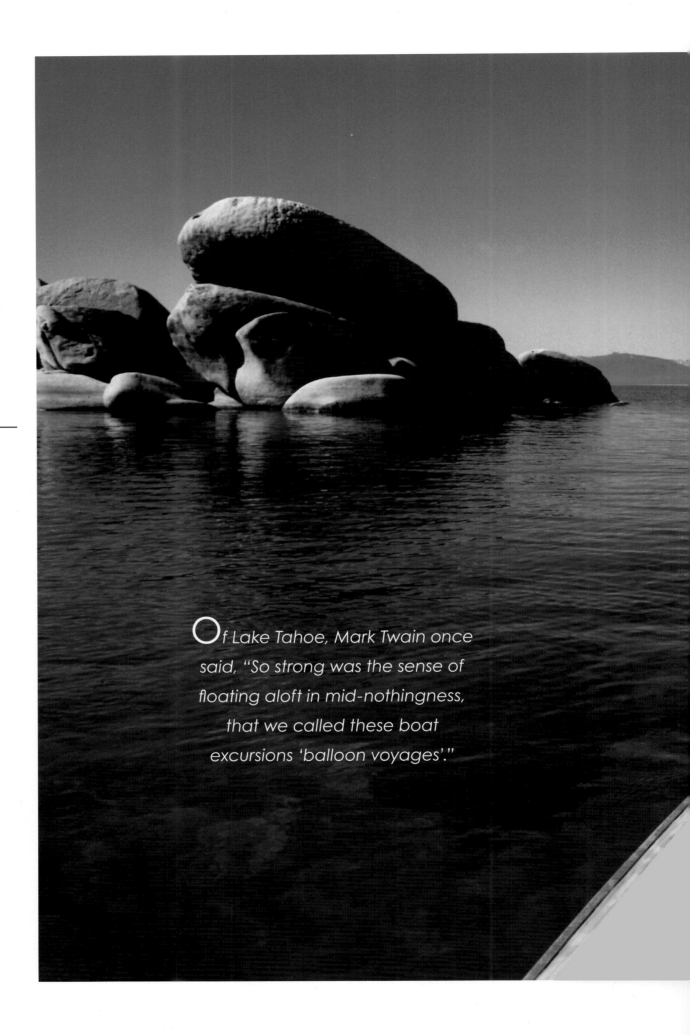

Of Lake Tahoe, Mark Twain once said, "So strong was the sense of floating aloft in mid-nothingness, that we called these boat excursions 'balloon voyages'."

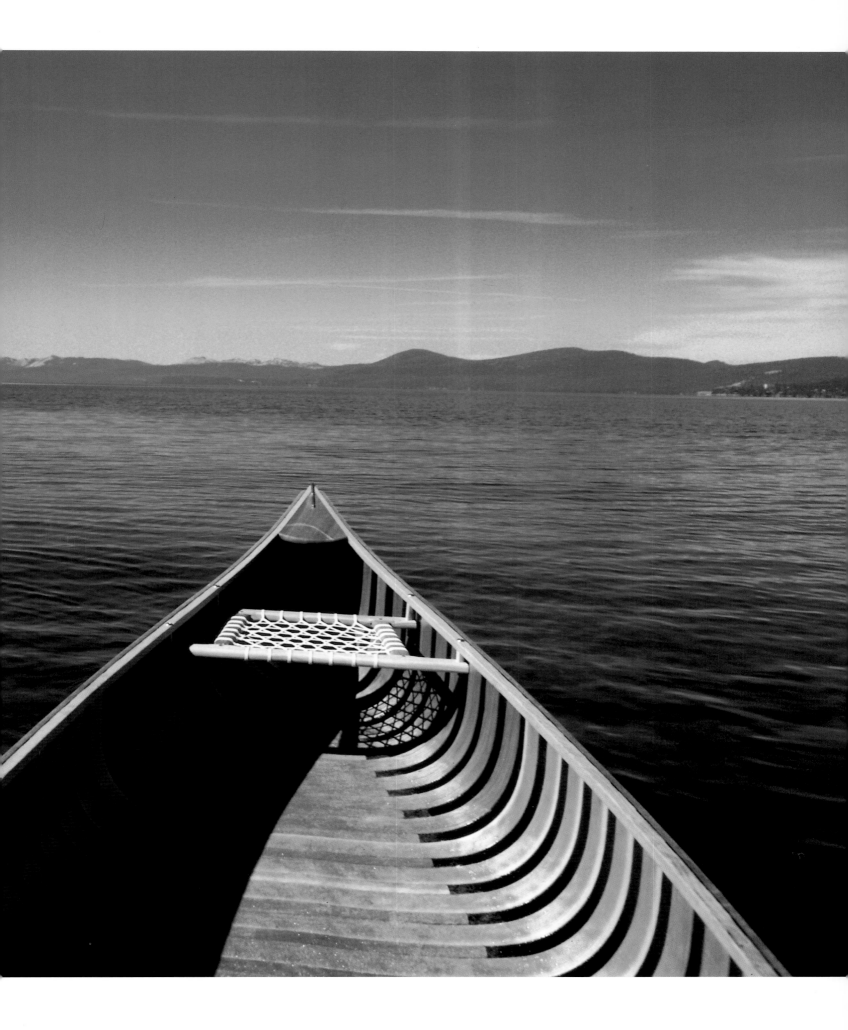

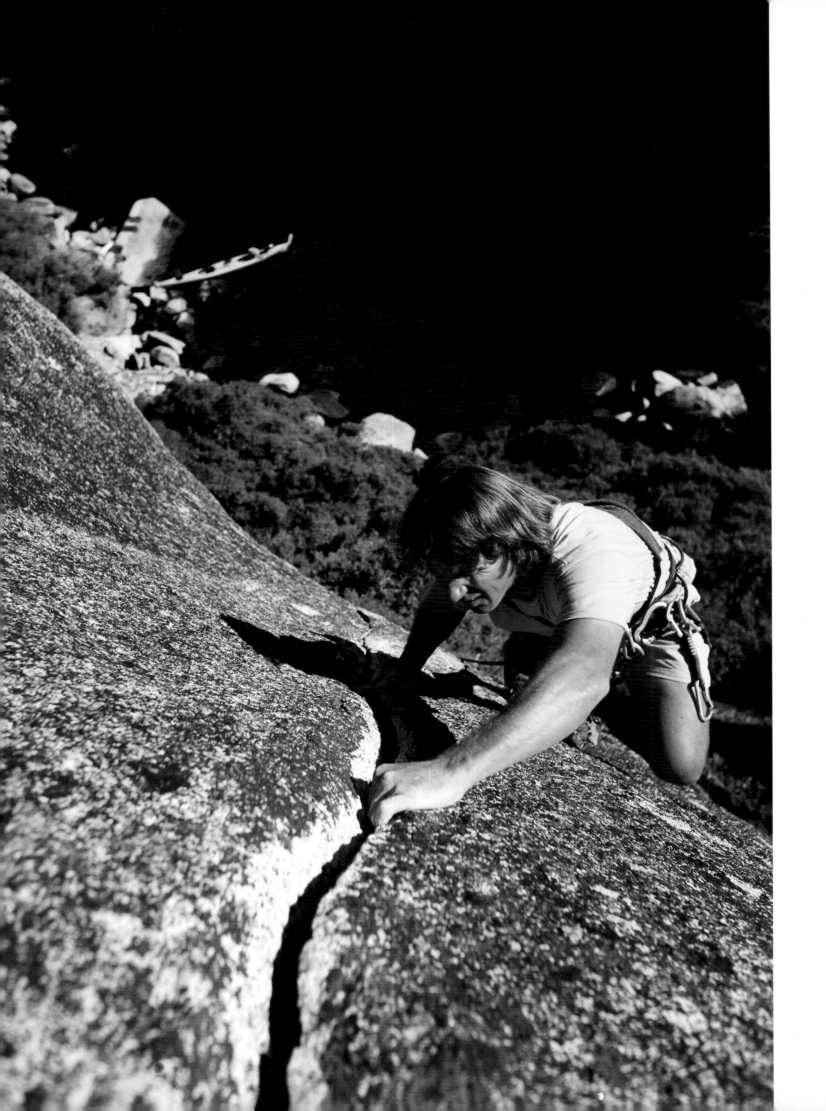

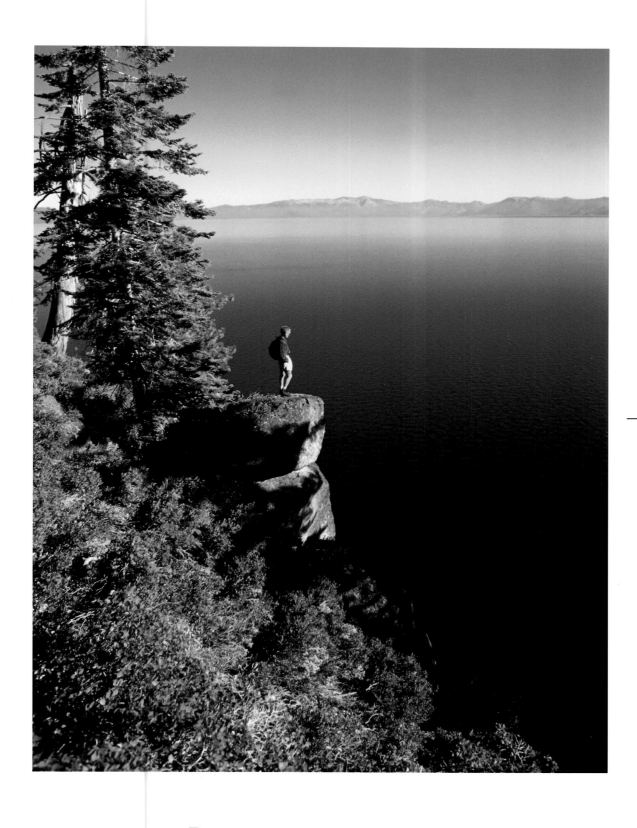

Rock climbers find physical and
fearsome challenges, while hikers
find sublime rewards such as these at
Tahoe's shores.

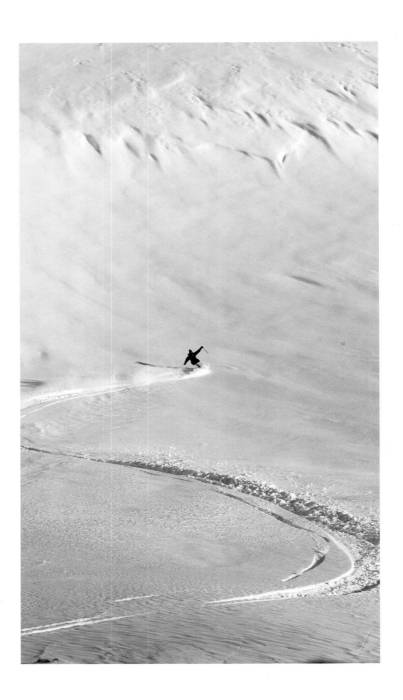

Carving the first run into new
snow is intensely satisfying.
*Right: Family enjoys a hike at Mt.
Charleston, near Las Vegas.*

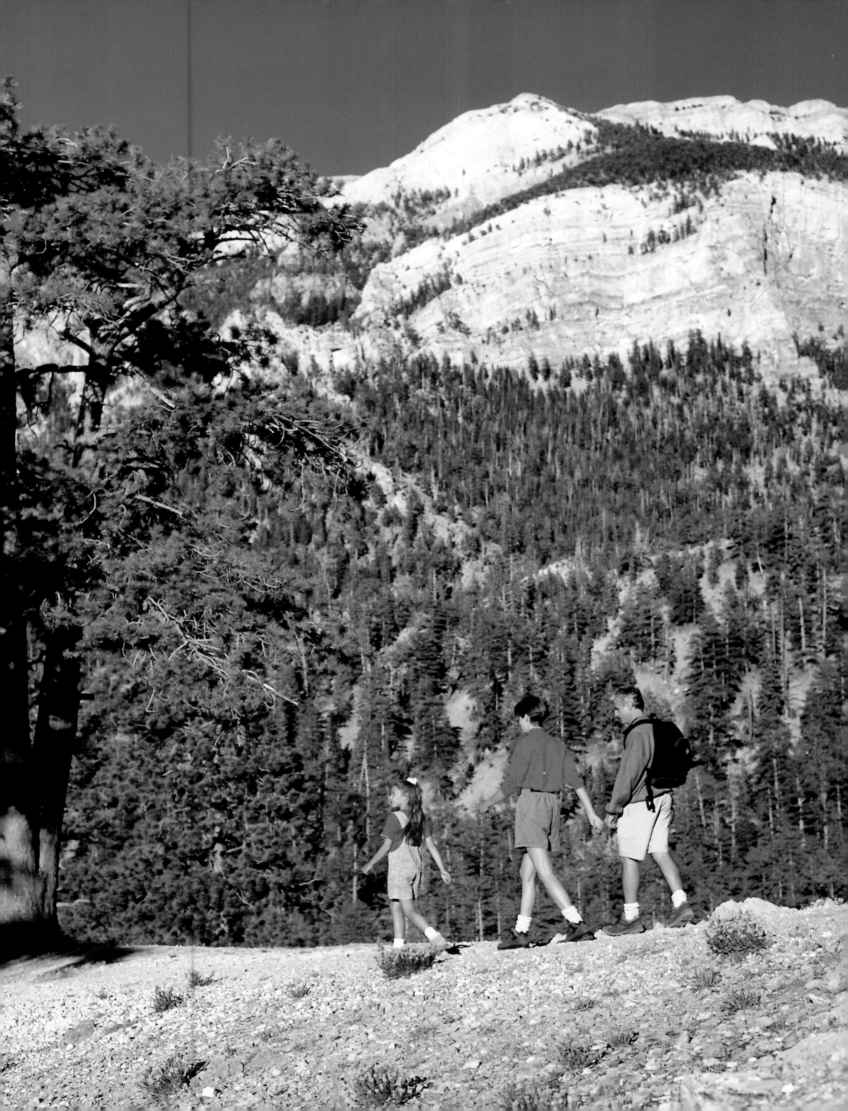

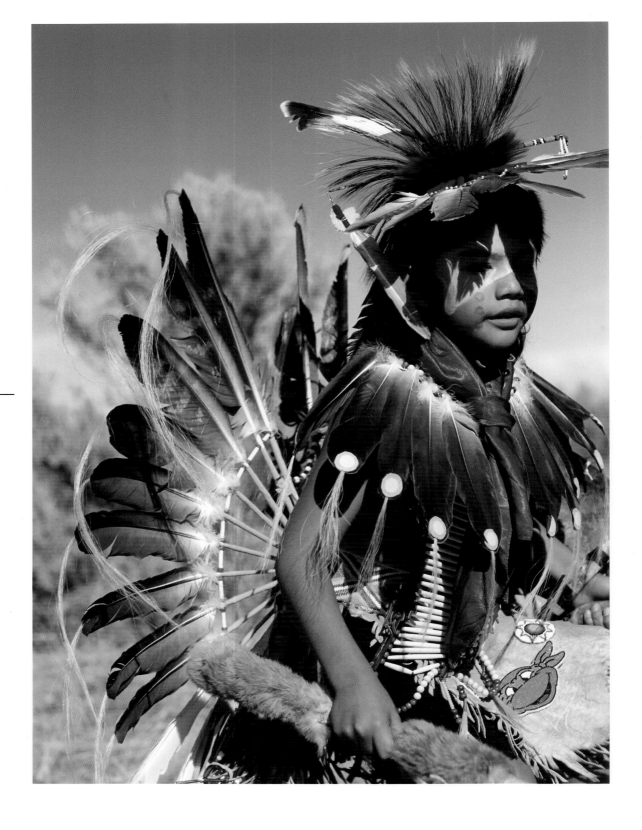

*This Pyramid Lake Paiute boy celebrates his cultural heritage at a powwow in Carson City. Right: Fly-fishing on Spooner Lake in the Carson Range.*

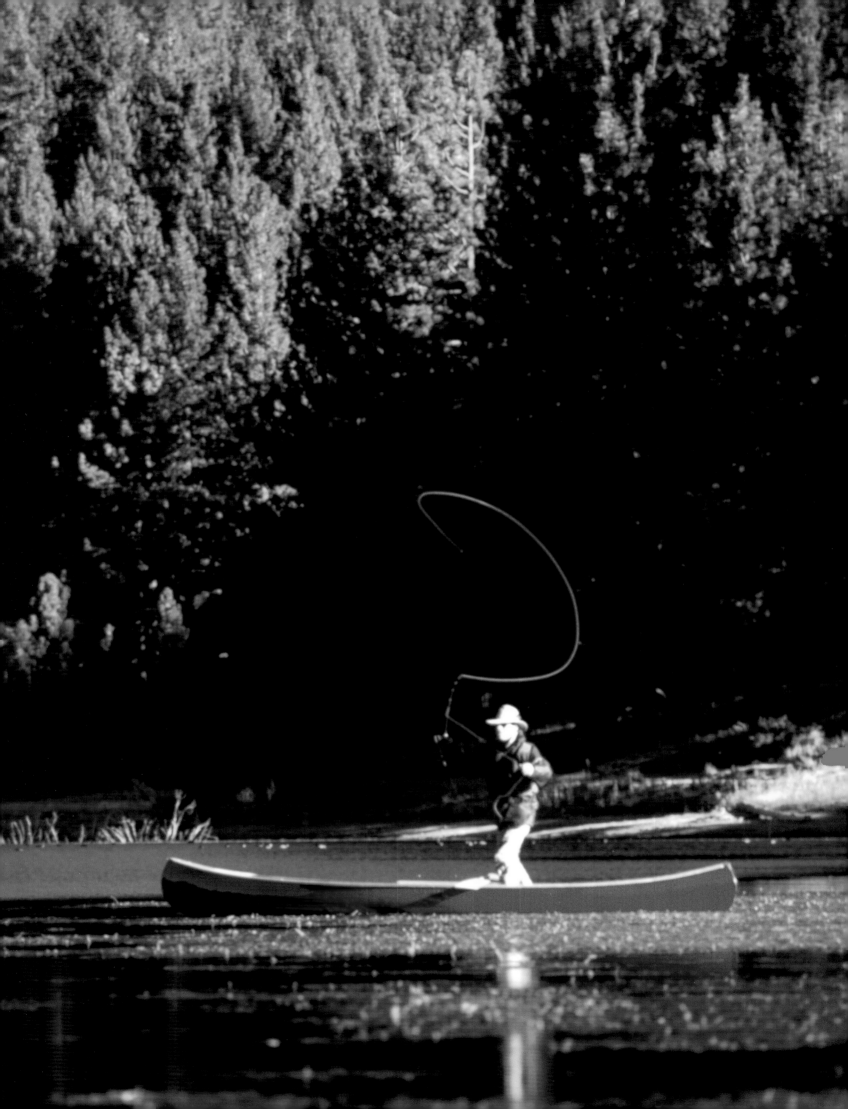

A sunset reward for those willing to chase it. Right: What simply is a rock cliff to be admired by some, is a challenge to others.

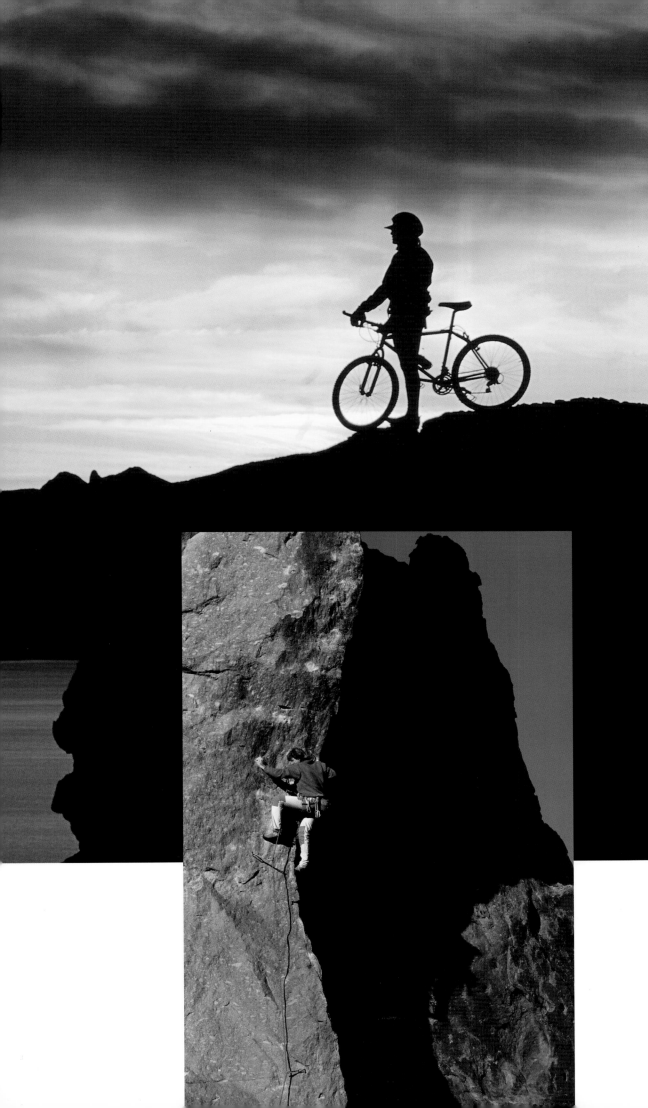

$G$olf courses seem like emeralds set around the sapphire lake. Inset: The Great Reno Balloon Race lifts off every fall.

# GATHERING PLACES

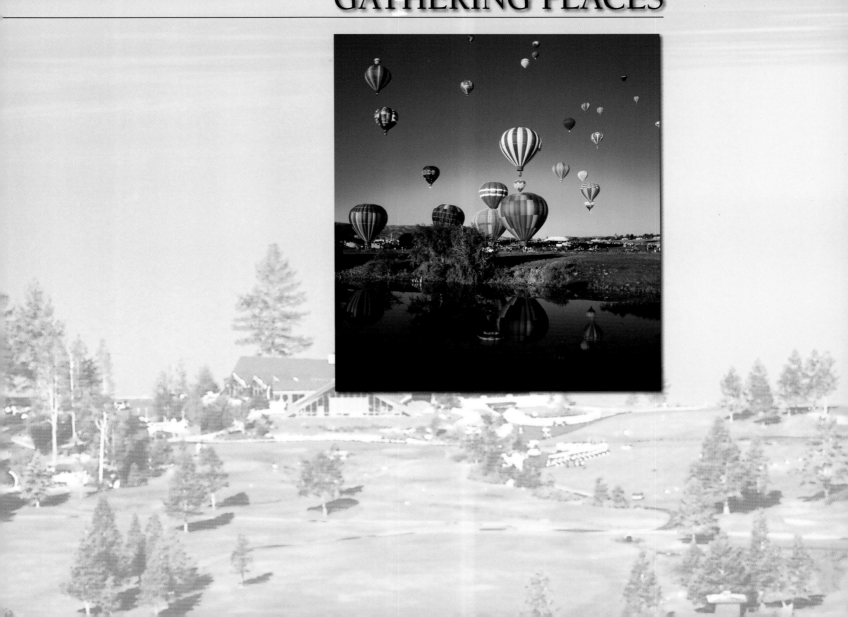

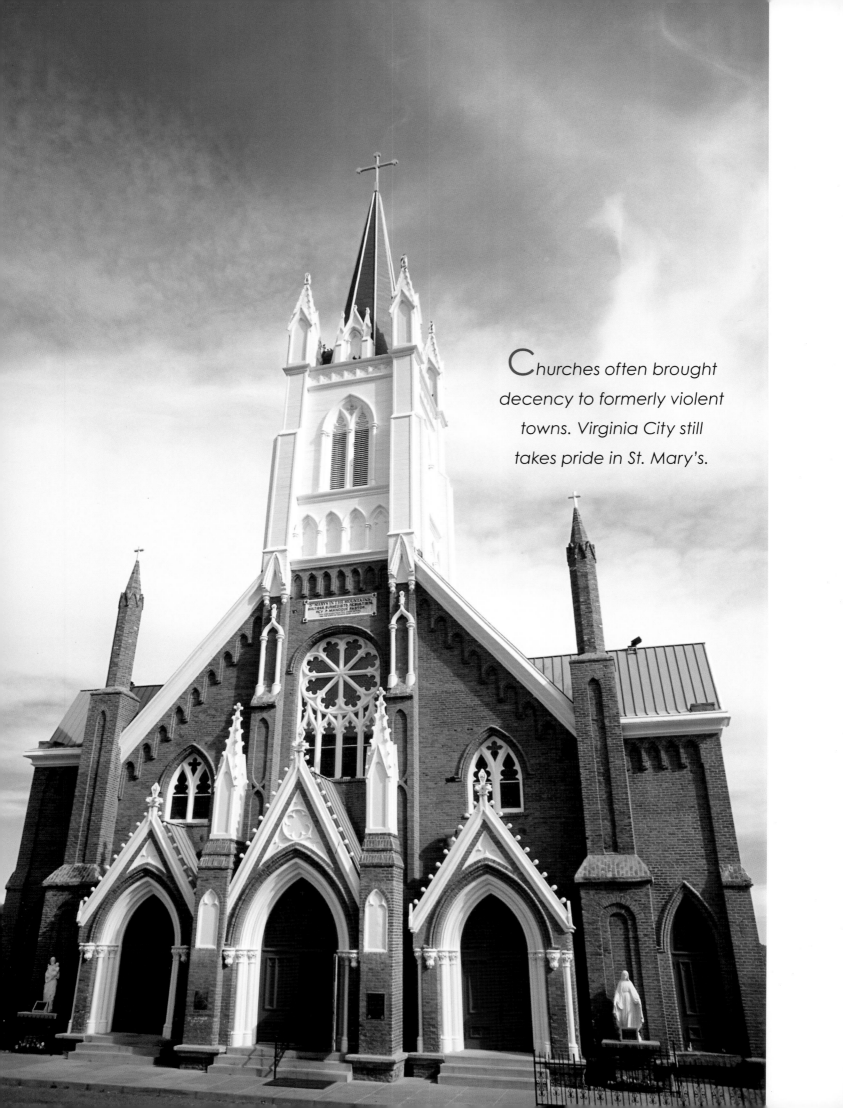

*Churches often brought decency to formerly violent towns. Virginia City still takes pride in St. Mary's.*

*"The cheapest and easiest way to become an influential man and be looked up to by the community at large was to stand behind a bar, wear a cluster-diamond pin, and sell whiskey."*
—Mark Twain

Saloons have long been rural Nevada's social clubs, political meeting halls and psychiatry couches. Intimate secrets, heated words, unkeepable promises and tall tales have all been passed at least a time or two over a beer. In most small Nevada towns, the local watering holes are the places where nearly everyone meets, at least sometime during the week, to swap gossip, make deals, or just socialize. If a small town is perceived as something organic, then the saloon is its soul. It is where opinions are formed, decisions are made and, occasionally, consensus occurs.

While the alcohol certainly helps loosen tongues and encourage talk, it's not necessary to drink in

order to be part of the scene. Indeed, in many cases, small towns don't offer much in the way of entertainment. When there's no movie theater, the satellite dish seems to be pulling down only reruns and you've already seen every tape available at the local video shop, the saloon beckons as a place to visit friends, play a little pool, toss a few coins in a slot machine and be yourself.

Bars don't care if you're rich or poor, high-bred or white trash. Sure it helps to have money when you're feeling magnanimous and offering to buy a round for the house—but most small town bars accept credit if they know you.

And, of course, the small town politician knows where to find a few votes before every election, provided his most hardcore constituents are sober enough to find the polling booth on those first Tuesdays. The cagey pols prowl the evening clubs, stopping in at each for an hour or so to renew acquaintances, talk a little zoning, shake a few hands and tell an off-color joke. In some towns, it's not uncommon that a city council will finish up a late night meeting and informally reconvene at a favorite watering hole. Naturally, official business is never discussed, the meeting is properly noticed in conformance with Nevada open meeting laws and the sun is shining at midnight.

Historically, the first business to open in most Nevada mining towns was a saloon. Sometimes, there would be dozens of saloons in a town of a few thousand people—it's estimated that Goldfield had one bar for every 132 people in 1908. Some towns would have saloons, followed by general stores, assay offices, hotels, restaurants and even newspapers, long before they ever built a church. A church was nice to have but a saloon was a necessity.

Indeed, only in Nevada would a town take its name from a saloon. In 1908, the Western Pacific Railroad was laying track through eastern Nevada. About 15 miles south of Wells, the railroad erected a construction camp for its workers. According to the story, one of the tents was designated a bar, which a slightly inebriated patron decided to identify with a handmade directional sign. Others came along and misread his crude sign, interpreting it as the name of the camp. Thus, "Tobar" came into being.

Sometimes, even after the ore ran out or the railroad closed down its station, and a town would begin the slow process of becoming a ghost, the saloon would survive. In a half dozen desiccated towns across the state, like Belmont, Manhattan and Goldfield, you might not be able to find a bank or a laundry—but you can still get a cold one.

## Drinking to memories

The McGill Club in eastern Nevada hasn't changed much over the years. While McGill has gone from a once-thriving copper mining company-owned town to a sleepy bedroom community for nearby Ely, the McGill Club has remained one of the few constants. Other businesses have come and gone—the movie theater has been closed for years, the massive copper smelter was removed a year or two ago and the drug store hasn't been open for more than a decade—the McGill Club has survived.

It's a classic old-style saloon. While the outside isn't much, the interior is dark, mysterious and, yet, inviting. A massive, ornate, mirrored dark wooden back bar—built on the East Coast in the last century and shipped around the Horn in 1907 (those early Nevadans spared no expense in furnishing their saloons)—sits against the south wall, with the barkeep standing between it and a matching long, narrow bar counter. Bottles of various spirits line the back bar shelves, giving the appearance of an apothecary's shop. There is a large jar filled with those unnaturally red, fat, hot sausages floating in cloudy brine. There is a wire rack filled with bags of beer nuts. You never see such snacks anywhere but in a bar. A television set with the sound off shows speedboat racing.

The wizened bartender named Norm seems like he's been there forever. He knows everyone who walks in and what they want to drink. Then he jokes, he's new in town and hopes the owner lets him stay on—he's only been there 55 years.

The conversation drifts to the new state prison outside of McGill and all the new people it brought to town. On the one hand, says one man wearing a baseball cap with an indecipherable emblem, it's good because property values are rising and businesses are doing better. But on the other hand, few of the prison jobs seem to have gone to local people, and there's the arrival of the prisoners' families, most of whom have no

*Gaming tables and one-arm-bandits draw crowds in watering holes and casinos in Las Vegas and smaller towns across the state.*

means to support themselves. He laments that he never had to lock the doors of his house and car until the last year or so.

Sometime later, the bartender asks me if I've "seen the wall," and leads me to a glass display case that covers much of the wall near the entrance of the club. Dozens of black-and-white photos of smiling young men in uniforms are in the display. He proudly explains that McGill has always been an ethnically diverse town, with many Greeks, Irish, Slavs, Italians and other groups, brought in to work at the smelter. As those groups became assimilated into American life, many of the sons of these immigrants joined the armed services to fight in various wars for their new country. The wall commemorates all the McGill boys who served in the military. Some of them never came home.

The mining company recruited these immigrants at places like Ellis Island, with promises of work in McGill. My late grandfather, born in Northern Ireland, was one of those who came to McGill to work in the 1920s. So accustomed

to the green of the Emerald Isle, I try to imagine what he might have thought when he arrived in dry, dusty eastern Nevada. My answer comes in remembering that he didn't stay long and moved on to Sacramento, where he found work with the Southern Pacific Railroad for more than 30 years.

It's amazing the things you think about in a bar.

### International clientele

In Austin, don't be surprised if you run into Elvis in a bar. Located in almost the geographic center of Nevada, Austin is so far from anywhere else that even the TV is a day late. Perhaps because of the relative isolation, Austinites have found other ways to amuse themselves.

"Did you know Bigfoot lives around here?" said one guy, wearing a cowboy hat and sipping on a Budweiser. "And I seen him. Honest."

He looked at me with a mischievous smile and his friend, sitting on the other side of him, nodded vigorously. I took a drink of my beer and looked for help from Butch, the bartender at Austin's International Hotel. He shrugged and began mixing a "fuzzy navel" for a woman sitting at the other end of the bar.

"Sure, and you've probably got UFOs out here, too," I said, recalling that Austin was the home of the legendary Sazarac Lying Club—and

thinking these guys were hoping to be charter members of a new chapter.

The guy in the cowboy hat, who was a mechanic, suddenly got serious and related to me that a couple of months ago, a man drove into his garage late one night. He said it was pretty obvious the man had risked burning up the engine by driving into Austin, but he figured the guy was worried about getting stuck out in nowhere.

When he asked the man why he'd not parked the car and hitchhiked into town, the man told him that he'd been driving on the road between Austin and Round Mountain when his engine suddenly died. Before he could get out of the car to look under the hood, the sky around him lit up like daylight. He tried to see the source of the light but it was too bright. After a few minutes, the light disappeared and he could start up his car. At this point, he smelled something burning and decided to head back to Austin, which was the nearest town.

> "Our town is so small we take turns being the town drunk."
> —Sign in Austin's Owl Club

"Didn't I see that in a movie?" I said.

The mechanic smirked, nodded and said he was equally skeptical about the man's story until he started to repair the engine. He discovered several parts of the motor were burned or melted, but not as a result of overheating. To this day, he said he has no explanation for the type of damage he found.

The two remained serious after the mechanic finished his story. I wasn't sure whether to believe them. At that moment, a jukebox in the corner, which had been silent until that point, started playing a country song. The weird thing was that no one had gotten up and put money in it.

"That's just the ghost of the International," said Butch. "He does that every half hour or so."

I feebly suggested that there must be some kind of timing device on the jukebox, to encourage customers to put money in to keep it playing. Butch said, sure that must be it, and winked, but didn't offer to explain.

Maybe the aliens were playing their song.

## The Barroom Museum

The late Julia Viani loved her saloon. Nearly every night for more than a quarter century, Viani worked behind the bar at Joe's Tavern, with her son, Joe, Jr., and other bartenders. Named for Julia's husband, who was a longtime state legislator, Joe's Tavern is part watering hole, part museum, part shrine and part junk yard. Until she was in her mid-80s and no longer physically able, Julia was always available and eager to take visitors on a guided tour of her place.

She liked to start her tour in front of a wall filled with old political signs, browning newspaper clippings and fading black-and-white photographs. She explained that she and Joe once had a bar in Virginia City before moving to Hawthorne. The rest of the story was on the wall: how her dog, now gone, was once written up in the "Ripley's Believe It or Not!" column for longevity; how she was once voted Miss Senior Mineral County; Joe's elections and political friends. There were letters from nearly every governor of the past few decades. There were other things the significance of which only she could explain.

Moving over to the bar, she talked about the various paraphernalia hanging from the back wall. Here were vintage firearms, old golf clubs and a large collection of baseball caps advertising various truck brands and construction firms. Then she'd lead you over to the wall near the bathrooms where she'd hung an antique tin bathtub from the ghost town of Rhyolite, various pieces of farming equipment and one of those classic barroom paintings of dogs playing poker. At nearly every object, she asked, "Ain't it beautiful?" before moving on without awaiting a response. One wasn't necessary.

## A parting glass

Pull into almost any little town out you'll find them: dark, smoky but friendly places where everyone knows your name. In Eureka or Austin or Battle Mountain, it might be called the "Owl Club," in Genoa, simply the "Genoa Bar" (it's also the oldest active saloon in the state, having started in 1866), while in Virginia City it could be the "Bucket of Blood," "The Union Brewery," the "Silver Queen" or the "Delta Saloon."

Ain't they all beautiful?

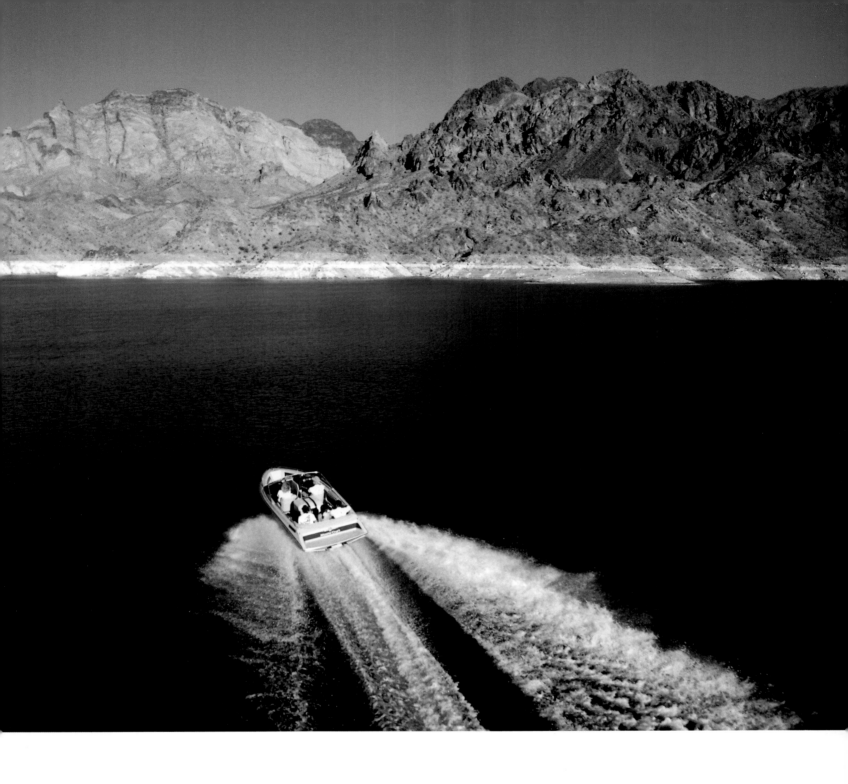

A different kind of watering hole
draws crowds too. Lake Mead
just east of Las Vegas is a boater's
paradise, and the largest man-
made lake in the West.

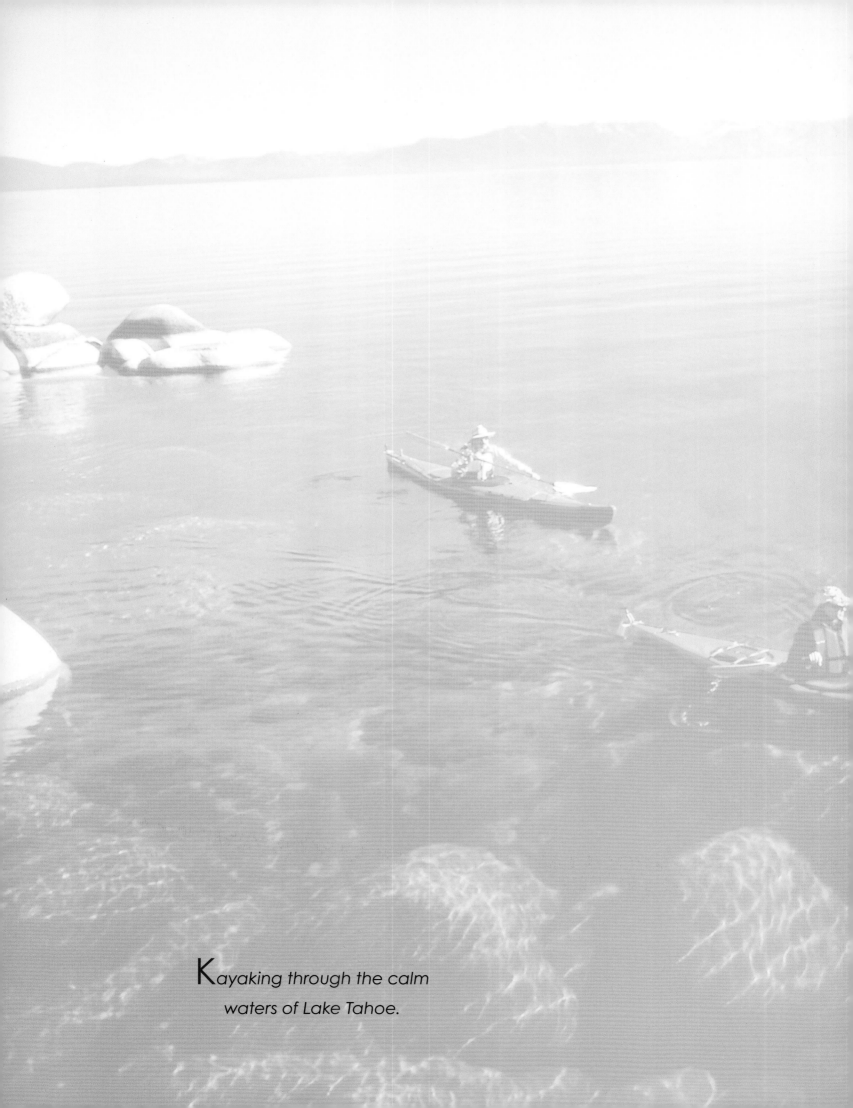

Kayaking through the calm waters of Lake Tahoe.

# THE PLACES

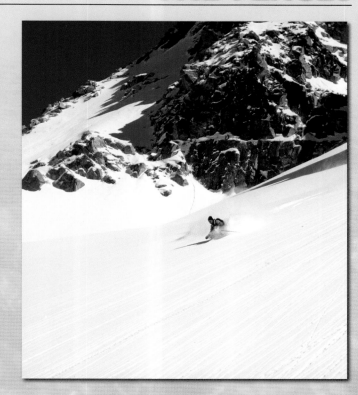

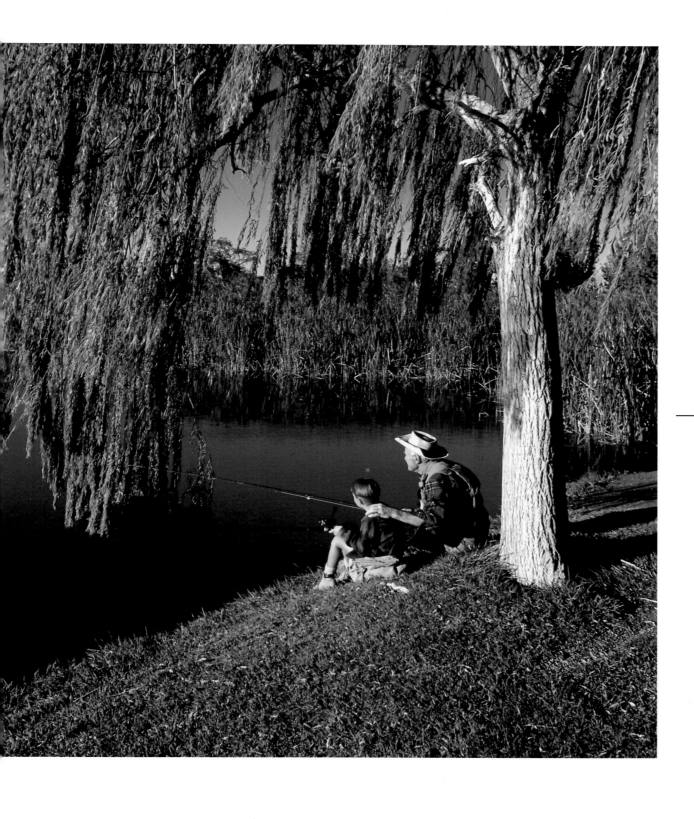

The Nevada state capital, Carson City,
grew with the mining boom in nearby
Virginia City. Above: Generations enjoy
fishing in Floyd Lamb State Park at Tule
Springs near Las Vegas.

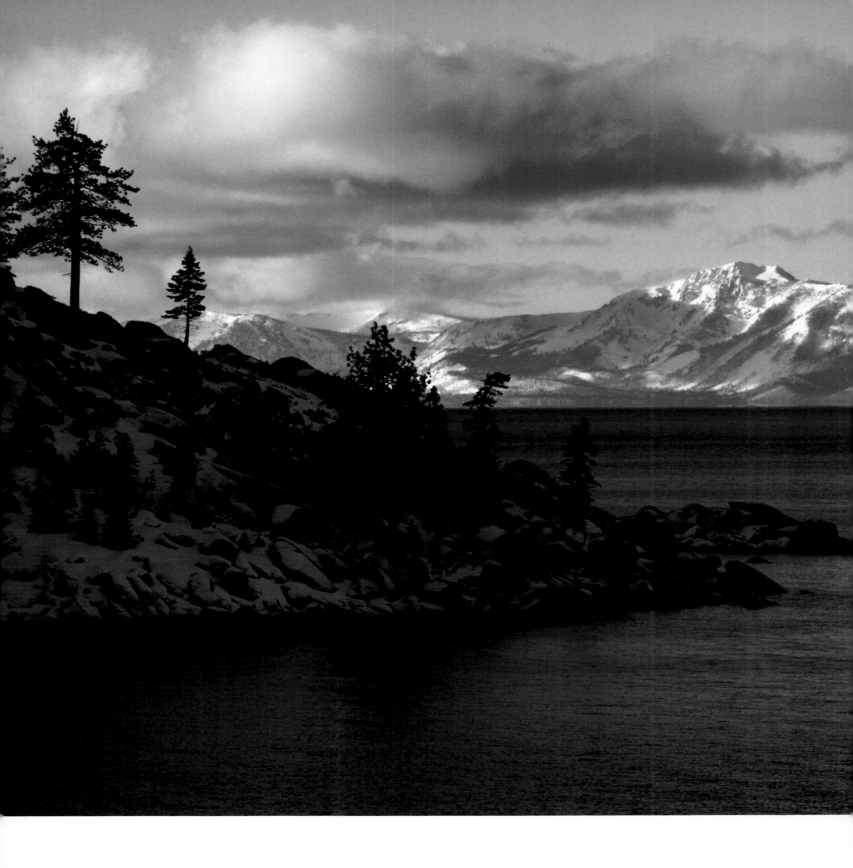

A clearing storm has left behind
precious snow on the Peaks of
Mount Tallac. Right: Floating above
Lake Tahoe's cold clear water
more than 1,600 feet deep.

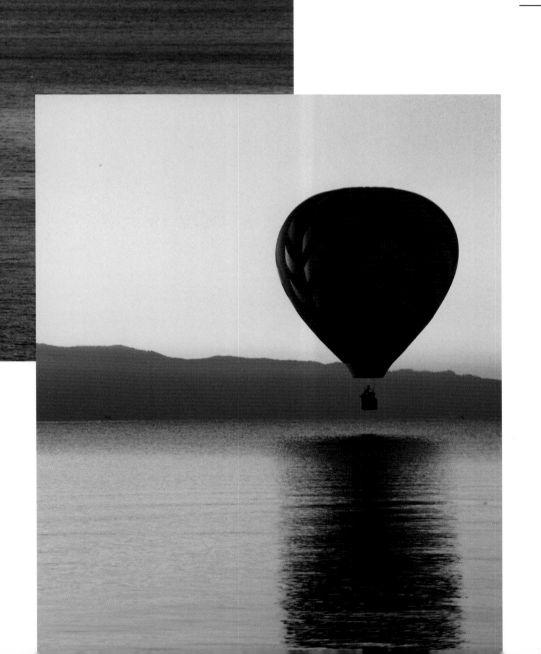

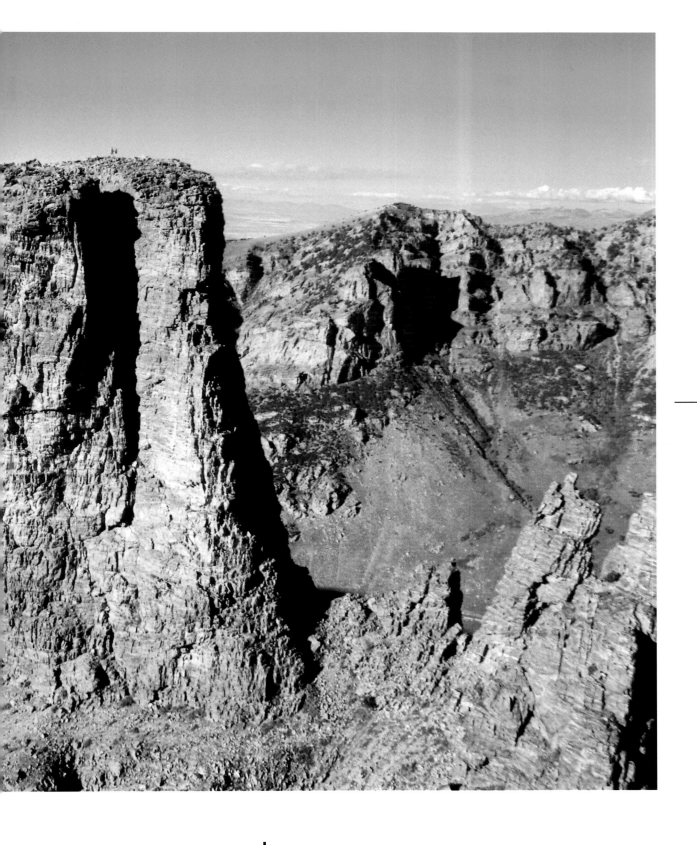

Looking very small atop a
pinnacle in the Ruby Mountains.
*Left: The Ruby Mountains glow in
the day's last rays of sunshine.*

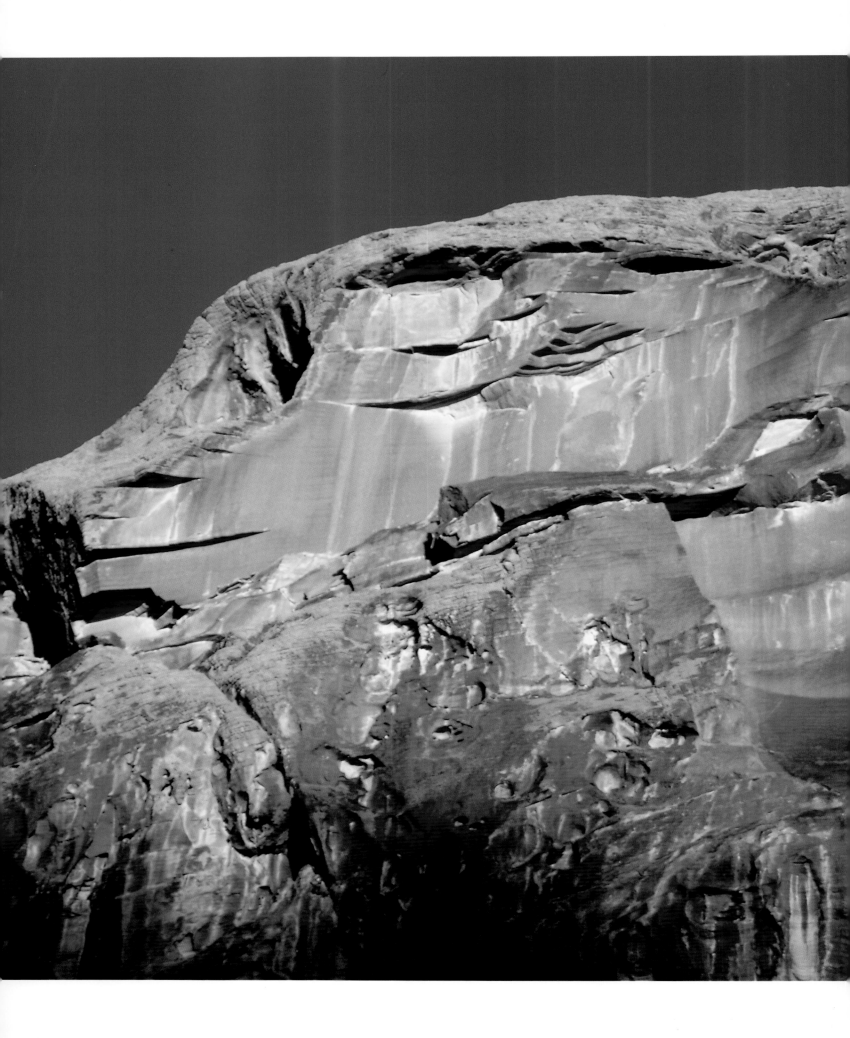

*Climbers come from all over the world to test themselves against the walls of Red Rock Canyon just outside of Las Vegas.*

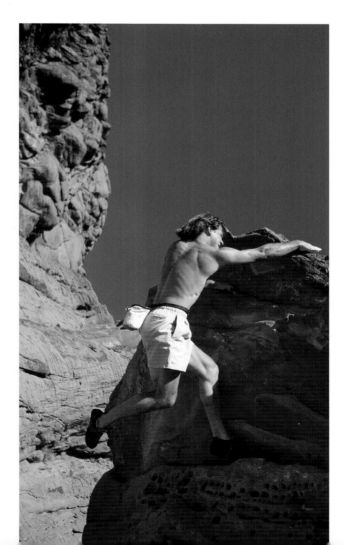

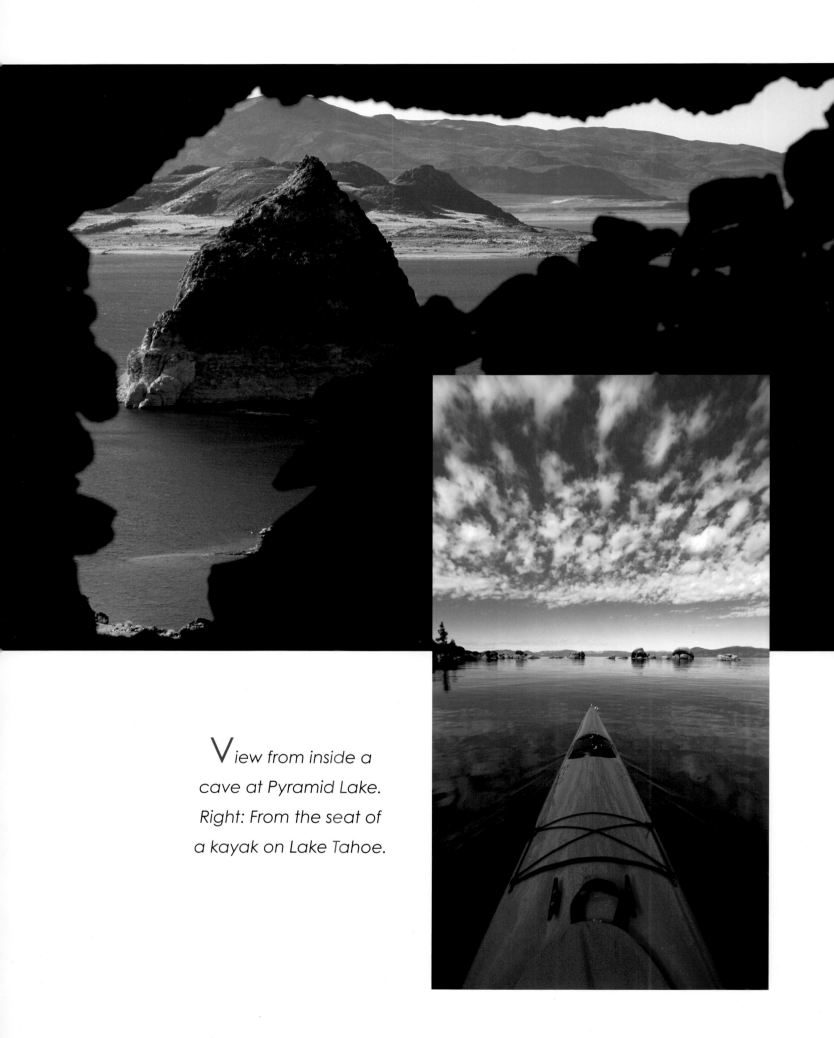

View from inside a cave at Pyramid Lake. *Right: From the seat of a kayak on Lake Tahoe.*

Aspens on Spooner Summit.

Short days and cold nights signal
the arrival of fall and inevitability of
winter at Jarbidge.

The Ruby Mountains are home to
Himalayan snowcock, mountain
goats, deer, mountain lions, and
wild trout. Right: Standing high
above Red Rock Canyon.

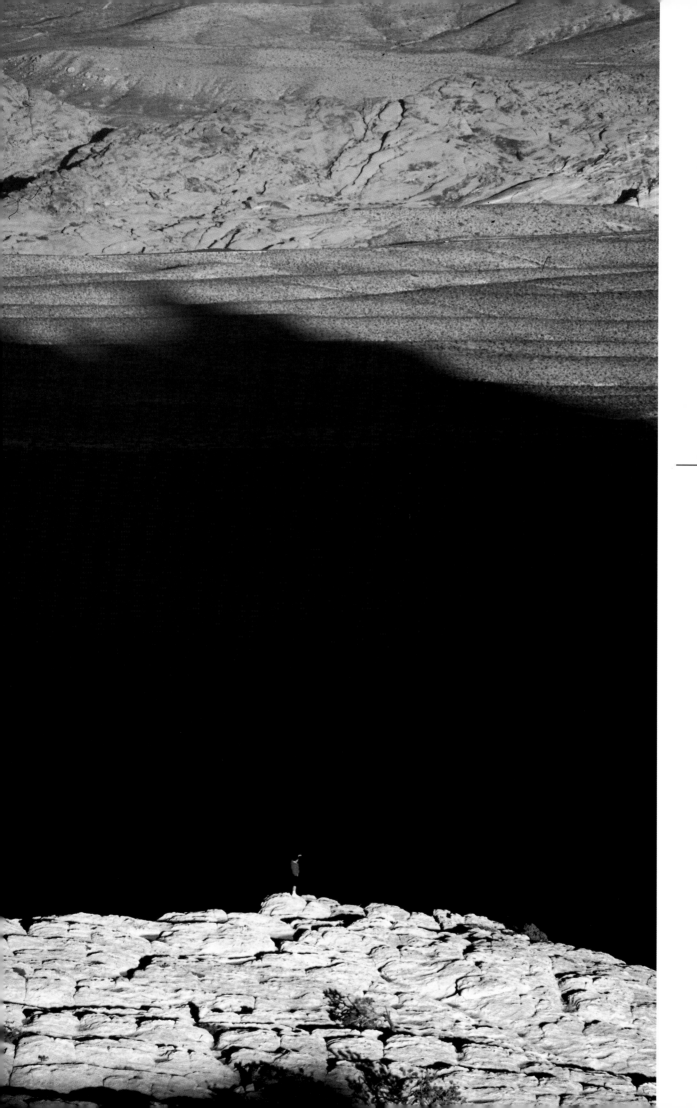

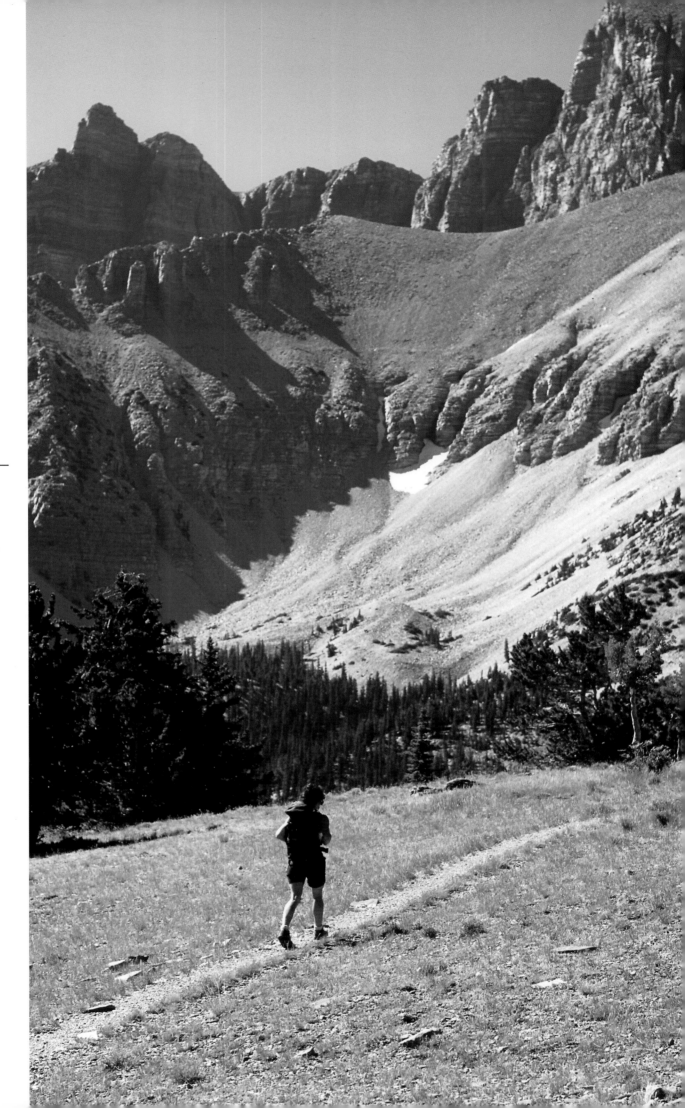

Isolated Great Basin National
Park offers elbow room to every
hiker. Above: The last rays of sun
lay down a surface of gold on
which to sail home.

# A COWBOY NEEDS A POEM

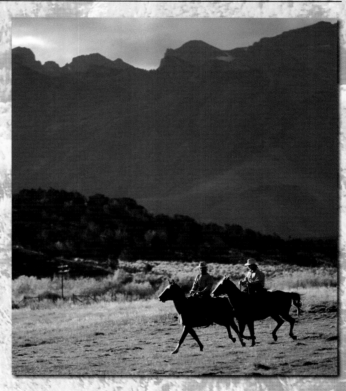

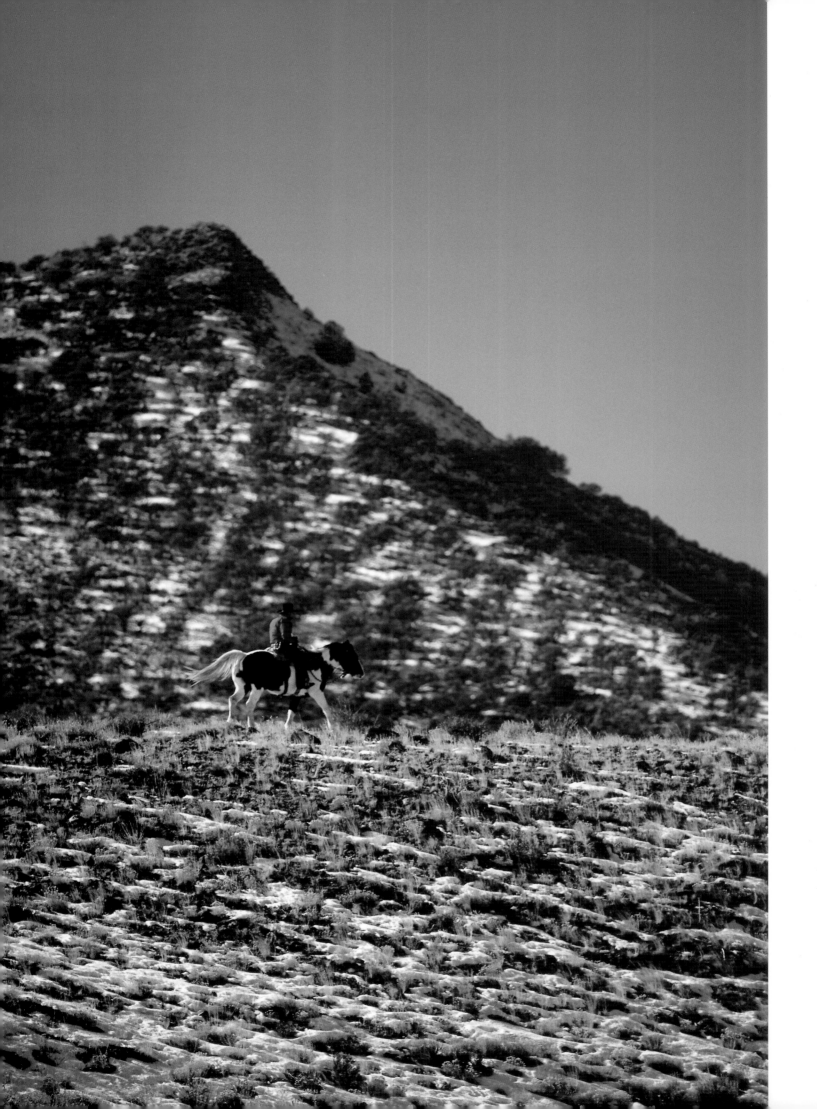

*"Just let me live my life as I've begun,*
*And give me work that's open to the sky."*
—Badger Clark

Cowboys have long been a part of the Nevada scene. While mining towns captured the spotlight during Nevada's initial rush to development, a few cattlemen were quietly settling around places like Elko, Winnemucca, Lovelock and Battle Mountain. Mining would alternately boom and bust, but ranching grew more slowly and with a more sustained impact.

Pioneers on the Emigrant Trail were the first to recognize Nevada's value for raising livestock. The desert's grasses proved nutritious to their animals as they followed the Humboldt River across Nevada. While they quickly exhausted forage along the trail, hundreds of meadows throughout the

state were filled with Indian rice grass, wild rye and wheat grasses that could support cattle and sheep.

By the 1870s, ranching outfits had cropped up throughout northern Nevada and the state had an estimated 400,000 sheep and cattle. Sadly, because few understood the fragility of deserts, this led to overgrazing which damaged much of the range. A severe winter in 1879-80 killed much livestock, and by the end of that season, many ranchers chose to depart Nevada for more hospitable territory. Perhaps not unexpectedly, this shrinkage in numbers of ranches coincided with the beginnings of giant cattle and sheep empires, which sprawled over much of Northern Nevada by the turn of the century. Among the largest were the Miller and Lux outfit, the holdings of John Sparks (who would become Nevada's Governor in 1903), and Pedro Altube's Spanish Ranch. For several decades John G. Taylor would have the biggest spread, owning some 60,000 sheep, 8,000 cattle, 130,000 acres of land and leasing another half million acres.

Although most of the ranching empires eventually splintered and faded, ranching continues to be an important part of Nevada's economy. The rural landscape, particularly in the valleys outside of the towns, is dotted with large and small ranch houses. Much of Nevada is still open range and drivers have to be careful, on a pitch-black evening, not to purchase an expensive quantity of beef. The law requires you to pay a rancher should you kill his cow.

Cowboys are part of what defines Nevada and the West. Despite having been overly romanticized in movies, books, songs and television shows, there really is something appealing

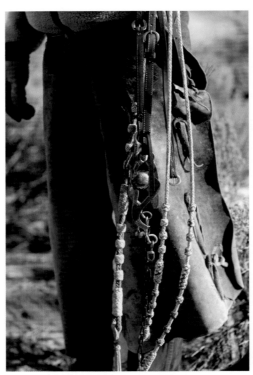

*Leather chaps are not antiques but work clothes for buckaroos, and the new bridle is handmade.*

about cowboy life. Perhaps it is the perceived freedom of living out under the stars, or the way the cowboy myth neatly parallels traditional American beliefs in self-determination and hard work. For whatever reasons, cowboys fascinate us.

Of course, the real life of a cowboy can be backbreaking, tedious and lonely. The day begins early and, depending on the time of year, can involve everything from feeding cows, to repairing barbed wire fences, to fixing corrals, to searching out lost calves, birthing them, castrating them, and branding them. The cows are stupid and stink. Cowboy hours dwarf the standard 40-hour workweek. The pay is awful. Yet some choose to do it.

## A bard's beginning

Bruce Mitchell truly believed in Roy, Hoppy, Lash and Gene. As a young boy he sat in the darkened theater in small-town Elko and watched his cinema heroes rescue damsels, slug it out with bad guys and, sometimes, sing a song before riding off into the sunset.

Unlike most boys, who could only fantasize about roping, riding and round-ups, when Bruce left the movie house he went home to the real thing on the ranch where he grew up. And he didn't mind the realities that movies never showed, like mucking out the barn, rising early to feed cows or riding for hours in the rain, checking for breaks in the barbed wire fences. All he ever wanted to do was cowboy.

The stories he heard while doing it were as good as the movies. Older ranch hands, grub-line cowboys and his father would tell of buckaroos and horses and coyotes and rattlesnakes and wide-open ranges. Frequently, the stories

were told in rhyme, which made them easier to remember and certainly easier on the ears when you heard them over and over.

Bruce was a smart boy and found he was pretty good at memorizing those poems. He could always attract an audience when he told of *The Strawberry Roan*, *The Bunkhouse Orchestra* and *The Flying Outlaw*. Pretty soon, the buckaroos started calling him "Waddie,"—slang for a common cowboy .

"They called me Waddie because I was my Dad's little 'waddie'," he says. "I hated that name but it stuck. Of course, now I don't mind."

Waddie worked on his dad's spread and at other outfits until Uncle Sam sent greetings. Expecting a tour of Vietnam, Waddie was shipped to Colorado instead. He spent his military career breaking horses on a ranch that provided mounts for military parades and honor guards. Back in civilian life, he became ranch manager on a small spread in the tiny northeastern Nevada community of Jiggs.

And he continued to recite cowboy poems.

### Why poetry?

Cowboy poetry is believed to have its roots in the fact that cowboying is a lonely life and buckaroos must find ways to pass the time on horseback while watching cows. Some simply made up stories, but others put their stories to song or rhyme, probably to make it easier to remember the exact, best order to repeat it. Later, when cowboys reconvened at meal times, a few screwed up the courage to share their songs and poems.

Mostly, the poems were about breaking a spirited horse, chasing off pesky coyotes and bears or, in a more philosophical vein, the meaning of the cowboy life. Some would be humorous, even downright crude, while others were sentimental and, occasionally, maudlin. Always, they were heartfelt and genuine — a lot like the men who were reciting them.

In January 1985, Waddie Mitchell and a few dozen other cowboy poets from around the west met in Elko, Nevada, for the first Cowboy Poetry Gathering. The event was organized by folklorists of the Western Folklife Center which is dedicated to preserving Western arts, crafts and traditions. Despite the fact that cowboy poetry has existed a long time and several books of it had been published about 1900, many of its modern practitioners were unaware others shared their avocation. Their gathering attracted national media attention and more than 700 devotees. The poets and their friends had such a good time they decided to try it one more time the following year.

Now an annual occurrence, the gathering has grown almost geometrically in interest and stature. Similar events are now held in every Western state. An entire industry of cowboy lore has bloomed, producing poetry books, videos, posters, tapes, CDs, and even a cookbook. A few poets even make their livings by performing.

### Icon of the art

Waddie is one of the most famous, and looks the part. In an earlier era he could have been taken for one of those movie cowboys, with his twinkly eyes and handlebar mustache. A Western-cut long-sleeve shirt, trademark round-crowned black cowboy hat with white trim, neatly cuffed Wranglers, high-heeled laced boots and knotted "wild-rag" wrapped around his neck, also look theatrical, but they're authentic and practical Northeastern Nevada buckaroo duds.

It's clear to anyone who has ever met Waddie Mitchell that he enjoys being a professional buckaroo bard. But he's not too far removed from his days as a cowboy and rancher—and you get the feeling he'd return to either in a minute if reciting poetry didn't pay so well.

In addition to reciting almost annually at the Elko Cowboy Poetry Gathering, Mitchell has appeared on numerous TV shows, been the subject of a PBS documentary, cut several poetry albums, and written a handful of books. He regularly tours with Western musicians, including Michael Martin Murphy, who is largely responsible for rekindling popular interest in cowboy music. Yet, despite his fame, one of the other things you notice about Mitchell is his infernal politeness. He's still one of those "Yes sir, no ma'am," buckaroos—like you used to see in the movies.

Roy, Hoppy, Lash and Gene would be proud.

# THE COWBOYS

*Nevada's wild horse population is much larger than that of any other state in North America. Below: A herd of horses on the move to a new range.*

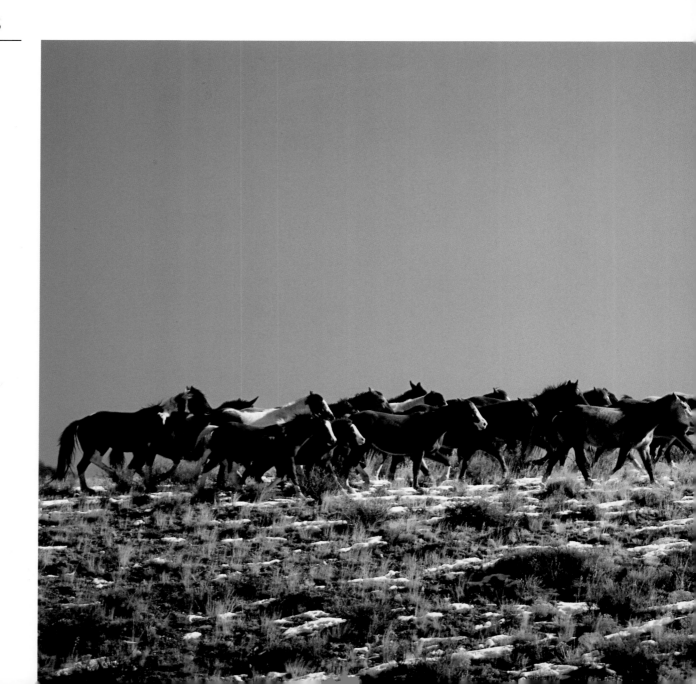

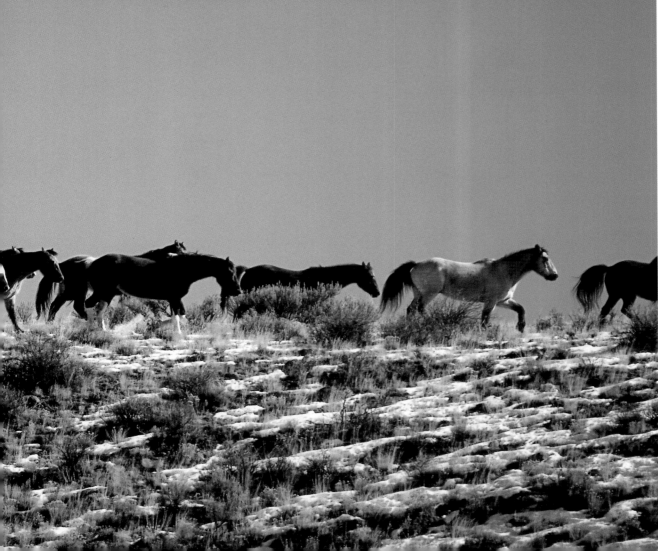

Midwinter pitchfork exercise.
Above: "Carson Valley plain" is the
setting for sad and sweet modern
folk tune, Darcy Farrell.

Modern day cowboys take city
slickers like these on trail rides in
the isolated Jarbidge Wilderness.

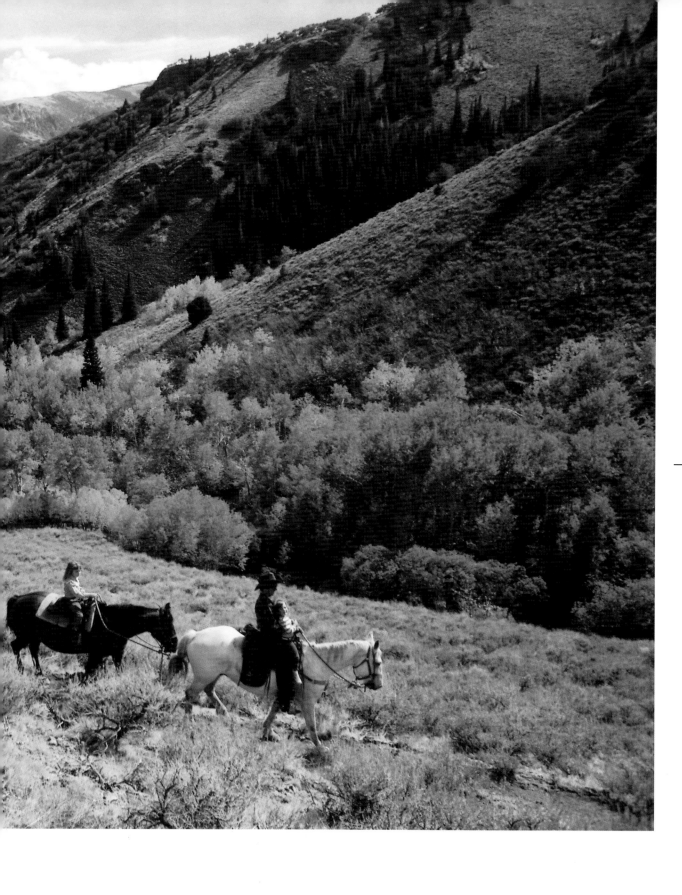

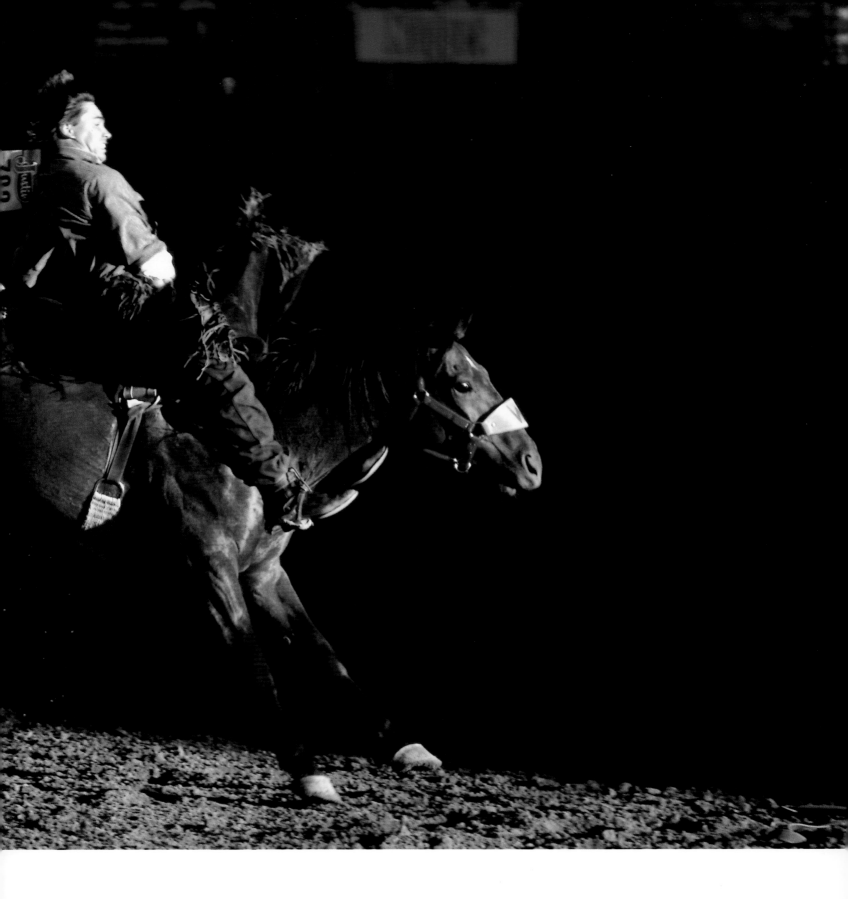

Cowboys from across the country
show their skills at the Reno Rodeo.
*Left: A rail fence makes a handy
resting place for tack.*

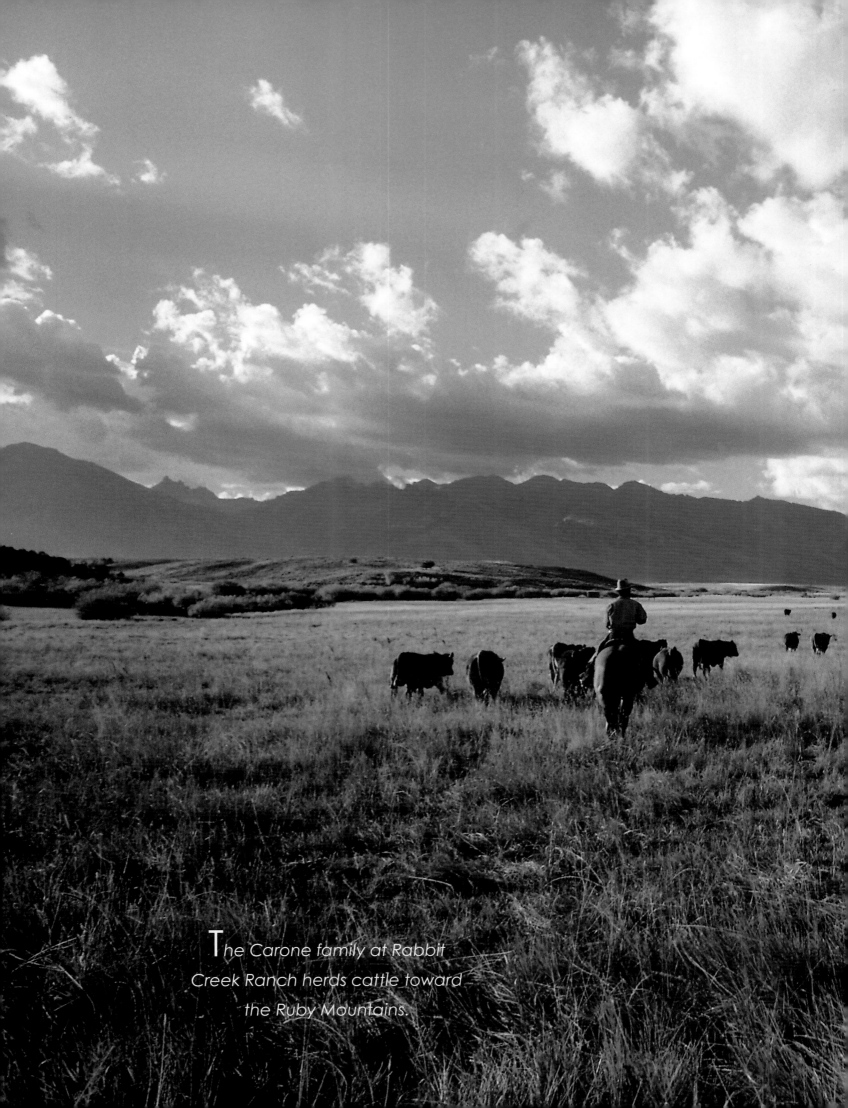

The Carone family at Rabbit Creek Ranch herds cattle toward the Ruby Mountains.

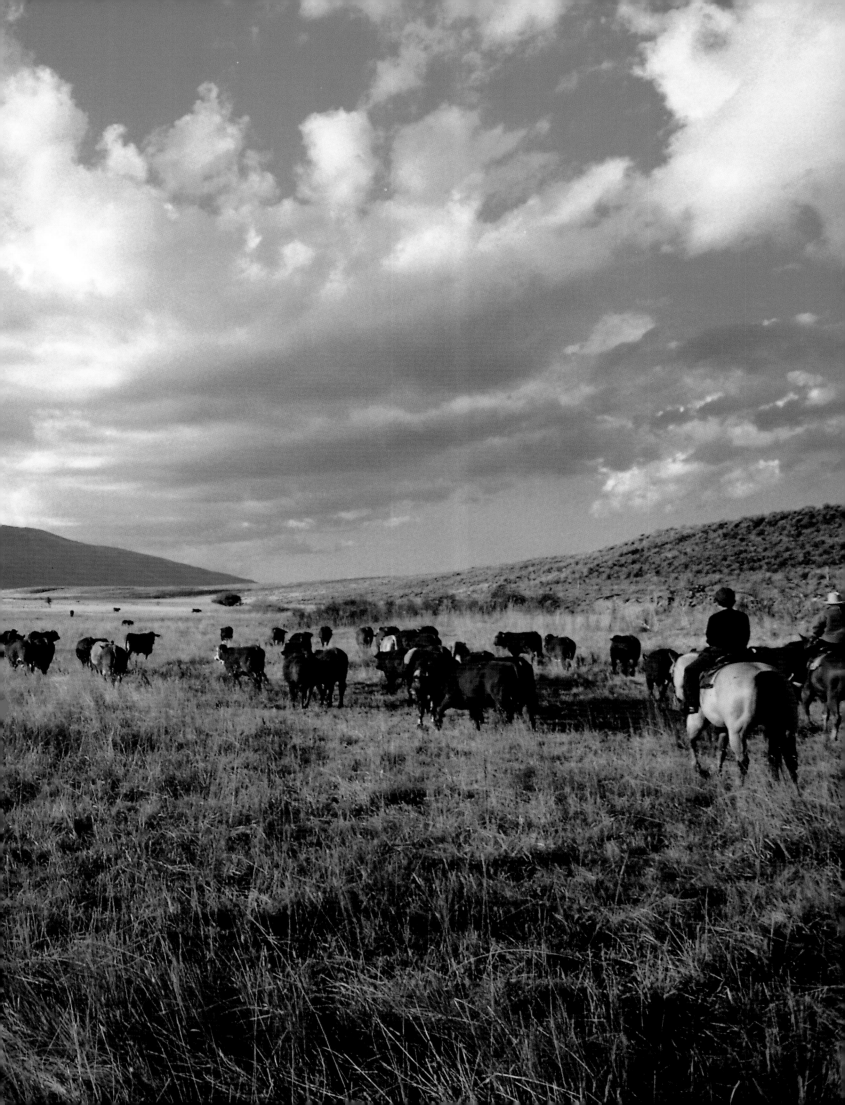

*Spring Mountain Ranch near Las Vegas was established in 1869. Past owners included munitions millionaire Vera Krupp and rich recluse Howard Hughes. Below: Fragments of assorted ranching tools retire outside a workshop.*

# AMERICA'S OUTBACK

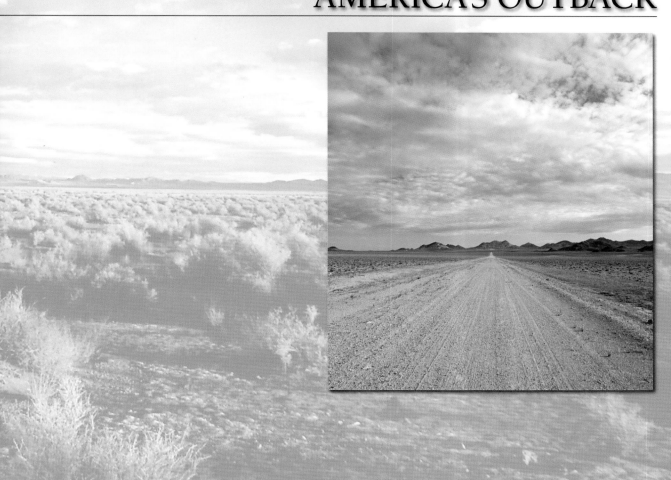

Bristlecones live longer than any other tree, but paradoxically, only in great adversity.

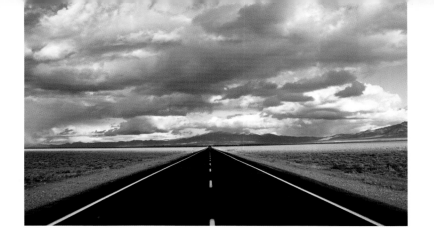

*"The Great Basin is . . . one hell of a long, dull drive."*
—John Hart

It's hard for people unfamiliar with Nevada to see anything but endless miles of empty, vacant land when they drive across the state. On the interstates, the monotony is broken by periodic roadside rest areas, and a string of small communities offering Formica-countered diners and truck stops. The interstate system is the pride and bane of America. While you can always count on adequate gas and food (or perhaps that should be in reverse order), there is a sameness to travel on the interstates. The burger in Nebraska is the same as the burger in Arizona. As the world has shrunk, so, seemingly, have the choices.

Fortunately, not all highways and roads are created equal. Out there, beyond the carbon-copy interstates, are a vast network of usually older highways that somehow have resisted homogenization and have maintained at least some semblance of uniqueness and character. While they don't offer the conveniences of four or eight lanes or regular rest stops, they do take you through nearly forgotten communities filled with fascinating and unusual people and sights.

In Nevada, this system of smaller highways includes U.S. Highways 50, 95 and 93—roads that transport you through what can best be described as the American Outback.

To truly begin to understand Nevada, you've got to know that the state consists of three elements—Las Vegas, the Reno-Lake Tahoe area, and the rest. Nevada politicians frequently call this last "the rurals," probably for lack of a kinder, gentler term. This great mass of territory, which encompasses most of the state's 110,000 square miles, was one of the last regions to be explored in the continental United States, and includes only about 15 percent of the state's 2.1 million people.

Perhaps because its people are spread so thin, there is something appealing about this area. This is the real Nevada. Certainly, this doesn't mean it's where or the way most real Nevadans live. (Numerically speaking, that honor would go to Las Vegas Valley, with more than 1.4 million people.) Rather, it is the place where you will find the essence of what makes Nevada different from Southern California or Maryland.

The American Outback is easy to parody or mock. A few years ago, in *Esquire*, novelist Tom Robbins wrote of his run-ins with the rednecks of rural Nevada who wear hats indoors and sit around in bars whining that "They didn't let us win in Vietnam." He called the state song an "exaggerated belch" and the "chicken-fried steak," the state bird. Perhaps Nevada should feel fortunate he didn't also declare the satellite dish as the official state flower.

But Robbins also admitted to at least some small amount of admiration for the honesty of these real Nevadans. Certainly you're not going to find Miss Manners fans in a place like the Owl Club in Austin, but you will find authentic folks. They might mumble over a beer about the "fukenpolitishuns" in Washington and Carson City, or claim taxes are "toogoddamnhigh" (despite the fact that Nevadans face lower taxes than virtually everybody else in America). But they're also folks just as likely to lend you a few bucks if you need it to pay the gas bill, or offer you a place to sleep if there's no room at the local motel. (I've been offered accommodations ranging from the top of a pool table to a child's bunk bed.)

Rural Nevada is a place where you can run out of gas on Highway 50—which *Life* magazine successfully labeled the "Loneliest Road in America"—and a local may drive up and offer to convey you back to Eureka (40 miles in the direction he wasn't going), wait for you to fill a gasoline can, and drive you back to your car. If anything similar ever happens in New York City, let me know.

> *287 miles of no billboards, neon or traffic jams. Sounds good to me.*
>
> —Dan Rather

Speaking of Eureka, a California woman told me, a few years ago, about an experience that began when she and her Nevada-reared husband visited relatives there. After spending the weekend, they decided to fill the gas tank on their Mercedes-Benz before venturing out onto the Loneliest Road. Her husband drove off without replacing the gas cap, and didn't notice it was missing until they were in Fallon, about 180 miles away. Since there are no Mercedes-Benz dealers in rural Nevada, they wrapped a piece of tinfoil over the opening until they returned home.

Five years passed before the couple once again visited Eureka, and once again refueled before driving home. The old garage, where they'd filled up previously, was closed, so they used a new gas station across the street. Her husband joked with the attendant that the last time he had been in Eureka, he'd left behind the gas cap off his Mercedes, so he would be more careful this time. The attendant asked him to wait a minute, then disappeared into a back room. He returned with a cardboard box, full of hoses, wires, plugs—and a distinctive gas cap

for a Mercedes-Benz. He explained that when the old station closed, the owner of the new one bought all of its tires and other stock, including this box of junk.

When you do business on the Loneliest Road, you hope those customers will come back.

## Asphalt lifelines

Nevada's back highways bear vehicles carrying gasoline, groceries, building materials and the other supplies essential to a small town's survival. Indeed, they are the main connection to the outside world for dozens of communities, particularly those where the freshest newspapers are a day or two old and television reception is downright ugly without a satellite dish.

Of course, it's always been that way. According to historian John Townley, the Nevada portion of modern U.S. Highway 50, which runs across the state's wide midriff, was opened in trail form by George Chorpenning, Jr., in the late 1850s. Chorpenning developed an overland mail route, called the "Jackass Mail" because he used mule caravans, and established a series of supply posts between Salt Lake City and Sacramento.

In 1860, after political and legal maneuvering, the Pony Express assumed control over Chorpenning's stations and used essentially the same trail for its famous mail service from St. Joseph, Missouri to Sacramento, California.

An actual road traversing the wide middle of Nevada was created in 1913 when the Lincoln Highway, the first transcontinental highway spanning America, incorporated this same route. Originally unpaved, the highway, nonetheless, captured the imagination of increasingly numerous automobile enthusiasts.

*The Complete Official Road Guide of the Lincoln Highway*, published in 1916, notes: "As one speeds over the Lincoln Highway in his modern automobile, it is hard to realize the slow moving oxen, painfully dragging the cumbersome 'prairie schooner' of '49, the women and children riding inside the canvas covered body, the stifling heat, the dust of the desert rising in choking clouds, the attacks by Indians, the want of water and sometimes food and all the suffering and yearning, with the births and deaths which must have occurred in that journey of six or seven months—an almost interminable journey which is made from coast to coast in twenty days with nothing but enjoyment from one end to the other."

Living in Lamoille means *being surrounded by tranquility and beauty.*

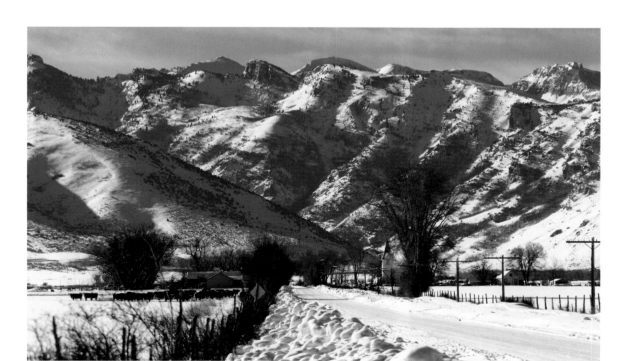

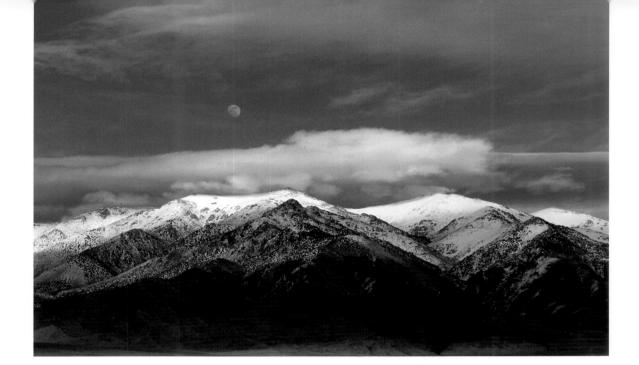

Now that's a ringing endorsement.

Paved sections of the road began appearing during the 1920s and '30s—often paid for by the automobile and tire companies, who were eager to persuade people to purchase a car. In fact, you can still find a plaque on the Eureka County Courthouse commemorating General Motors for funding 22 miles of paved road through that county. Additionally, cities, counties and states began paving roads in an effort to prove they were indeed civilized places to live and do business.

Today, Highway 50 is a two-lane ribbon of asphalt that passes through some of the last open range in the country. Out here, the cows truly do outnumber the people and penalties for hitting one with your car are nearly as stiff as for manslaughter. This is the basin-and-range terrain of the Great Basin. Long, narrow valleys bordered by waves of deceptively high mountain ranges. So much sagebrush that, if someone ever discovered a use for the stuff, Nevada would become the richest place in the world. Clear, endless skies that city folks can only dream exist. A thousand different species of rabbits, mice, bugs, birds, trees and shrubs that have managed to adapt and multiply in this hard land. And few people. As newsman Dan Rather once said of Highway 50, "287 miles of no billboards, neon or traffic jams. Sounds good to me."

Of course, other roads also span Nevada's Great Basin country, in a north-south direction, such as U.S. Highways 93 and 95. While that "Loneliest Road" label stuck to Highway 50, it would more accurately describe at least a few sections of Highway 93, along Nevada's eastern border.

Highway 93 is one of the longest roads in Nevada, stretching some 525 miles, from Jackpot on the Idaho border, to Hoover Dam, which bridges the Colorado River between Nevada and Arizona. Along the way, it passes through some of the most undeveloped and unspoiled country in America. After departing from the high, flat plateau country of southern Idaho via the small gaming mecca of Jackpot (only in Nevada could a town carry such a name), travelers on 93 enter the outer edge of the Great Basin. In the distance to the west is the magnificent Jarbidge Wilderness Area, while about 50 miles to the east lie the Great Bonneville Salt Flats.

South of Wells is one of the more dramatic stretches of the highway. Traveling down the middle of the wide Clover Valley, the road parallels the snow-topped, craggy heights of the east face of the Ruby Mountains and the fertile Ruby Marshlands. At a place like this, you can't help but want to pull off the road, sit on the hood of your car and thank your Maker.

Driving down the remote, uncrowded, eastern side of the state, the mind can wander, play tricks, conjur images. The hypnotic humming of radial tires on asphalt, the flashing by of an endless supply of yellow center divider lines, and a landscape so overwhelmingly vast that it never seems to change—all become part of your driving mantra. Clouds can become the round, open, fat face of a smiling newborn. Or they can paint ominous shadows on surrounding mountains, suggesting hidden places with

deep secrets. These lonely roads encourage introspection and contemplation.

Nevada writer David Toll once described some of Nevada's mountains as "like sleeping women, sprawling languorously across every horizon." Indeed, if you look long and hard enough, you begin to see something sensual in the curves and rises of these ranges. Of course, when you start to see women in the mountains, that is also probably a good indication that you should take a break from driving.

South of Ely, the highway edges the west side of the Snake Mountains and the Great Basin National Park, which includes Wheeler Peak, at 13,063 feet, the highest point completely contained in Nevada. (Boundary Peak in the White Mountains is a little taller at 13,145 feet, but it's partly in California.) The 77,109-acre park dramatically illustrates the basin-and-range terrain. A visitor can, in a relatively short time, go from the sagebrush and cacti of an upper Sonoran life zone, through forests of pinyon pine and mountain mahogany, to a frigid Arctic/alpine tundra life zone, found at above 10,000 feet. The characteristic plants of the alpine zone are groves of gnarled bristlecone pines, which can live longer than any other trees—more than 4,000 years.

Continuing south, Highway 93 passes through old mining towns, like McGill and Ely, where copper was once so plentiful it was used to make doorknobs and rain gutters, and Pioche, where silver mines were so rich that they were fortified and guarded by small armies of gunslingers. Other towns, like Panaca and Alamo, grew up providing fruits and vegetables to the mining towns, while Caliente owes its existence to a railroad now called the Union Pacific. Each has plenty of stories, some even true, worth telling and hearing.

### The western artery

But if Highways 93 and 50 can be said to take you through the soul of Nevada, then Highway 95, on the west side of the state, plunges you into its fiery heart. Stretching through the Mojave Desert, bordered by Death Valley, Highway 95 is a wild journey through some of the most rugged and challenging country in the state. This hot, dry terrain is closer to the more common images of Nevada.

Yet even here there is great beauty and diversity. Joshua tree forests, spiky yucca plants, mesquite bushes, greasewood and the always present sagebrush are but a few of thousands of plants and animals that not only survive but thrive in the western Nevada desert. Indeed, this may be the most biologically complicated, fragile place in the West. Some of the species that have managed to find ways to live in this harsh environment, paradoxically, are likely to be damaged by the most subtle environmental changes.

For example, while there are several endangered species of pupfish—a tiny, nearly transparent pollywog of a fish that has evolved in spring-fed waterholes of Western deserts—the rarest is found only in Devil's Hole, a flooded cave near the California line and Death Valley, where the water surface available to sunlight, and therefore able to grow food for the hole's fish, is not much bigger than a bathtub. Researchers have found that minor changes in water levels and temperature can affect their limited numbers. Since the water level and temperature is affected by the amount of groundwater pumped in the surrounding valley, and court decisions have accordingly limited the amount pumped, it's not surprising that the little pupfish hasn't endeared itself to local ranchers, farmers and would-be developers.

As in most of the state, the quest for minerals greatly aided in populating Western Nevada. Many of the townsites dotting Highway 95 owe their creation to the presence of gold and silver. Tonopah, Goldfield, Goldpoint, Rhyolite, and some towns that have since been reclaimed by the desert, were children of the early 20th century mining boom in central Nevada. Each of these mining meccas made a bid to become the newest Comstock Lode, then fizzled. Some, like Goldfield and Rhyolite, were spectacular in their failure. Others, like Tonopah, found new ways to survive, including tourism and the military (which has embraced the relative lack of population and remoteness for testing its secret projects and atomic bombs).

Traveling north past Tonopah, Highway 95 enters the southwestern edge of the Great Basin. The road travels by Walker Lake, near Hawthorne, one of the last vestiges of the basin's unique system of interior drainage. Like

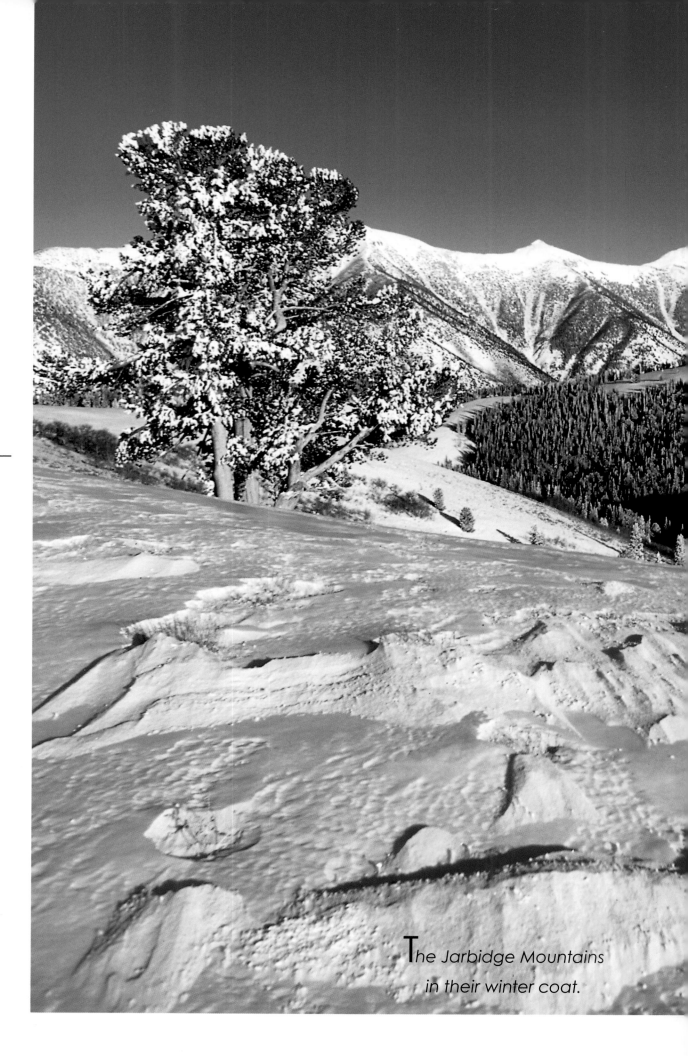

The Jarbidge Mountains
in their winter coat.

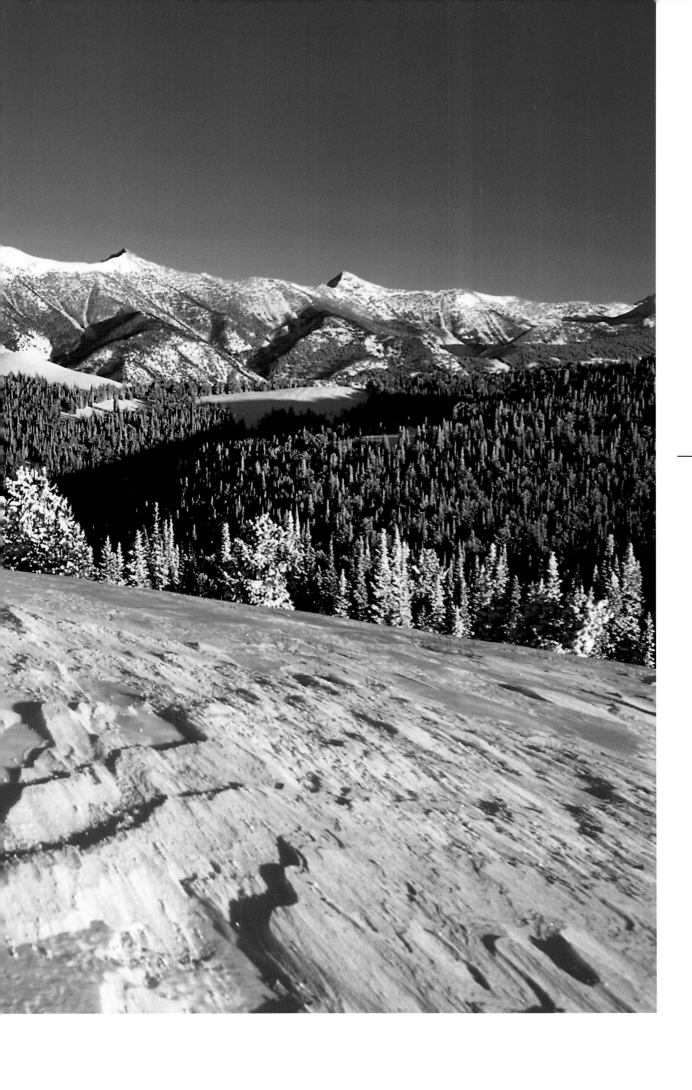

Pyramid Lake, to the north, Walker is one of those mysterious natural desert reservoirs that seem so out of place because they lack vegetation. The lake bursts upon your consciousness, perhaps because such a large body of water is so unexpected.

Highway 95 continues north through Fallon, one of the state's main agricultural districts, skirting the edge of the infamous 40-mile Desert, the absolute worst part of the Emigrant Trail across the West. The last drop of water and blade of grass were left behind at Big Meadows (now called Lovelock). The next of either wasn't for some forty miles, until the Carson River west of Fallon. Between was an alkali wasteland of soft, sandy soil that slowed travel and, for the many who couldn't or wouldn't continue, became their final stop. Dozens of mid-19th century emigrant diaries relate the danger, and the fears of those who encountered the desert and somehow survived its treachery. The trail across the desert was littered with abandoned wagons, dead livestock, furniture, trunks of clothing and other personal items—a veritable thrift shop of effects, for anyone willing to fetch them.

At the point where exhausted pilgrims reached the Carson River, an enterprising trader set up a post, which became known as Ragtown. The name was derived from the sorry appearance of the emigrants' clothing, which they washed in the river, then hung in the nearby cottonwoods to dry.

On Highway 95, north of Winnemucca, the road parallels the Santa Rosa Mountains and, to the east, Paradise Valley. The latter is an aptly named ranching area that, despite its beauty, has managed to be overlooked in most travel guidebooks. Set in the shadow of the Santa Rosas, a small community, also called Paradise Valley, is a Norman Rockwell-style hamlet with long-abandoned wood-and-brick frontier storefronts, fertile, green meadows dotted with cattle, horses, sagging wooden barns, and an occasional farmhouse. You might call it Paradise Found.

From here, Highway 95 continues its northern march through a tiny roadside stop called Orovada to the town of McDermitt, a former military outpost and Indian school, located on the Nevada-Oregon border.

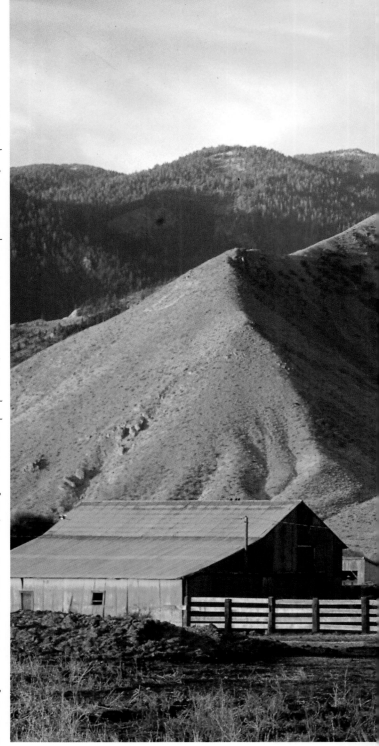

The long journey on Highway 95, winding from McDermitt to a spot on the Nevada-California border, about 75 miles south of Las Vegas, consumes some 600 miles and takes you through a remarkable range of temperatures, climate, topography, altitude and attitudes. In short, if you driven all of Highway 95, you've seen a big part of Nevada—and you probably deserve some kind of medal for stamina.

Nevada's rural highways are America's mythical open road, made manifest. Something almost spiritual happens when you drive along Highway 50, preferably in a convertible with

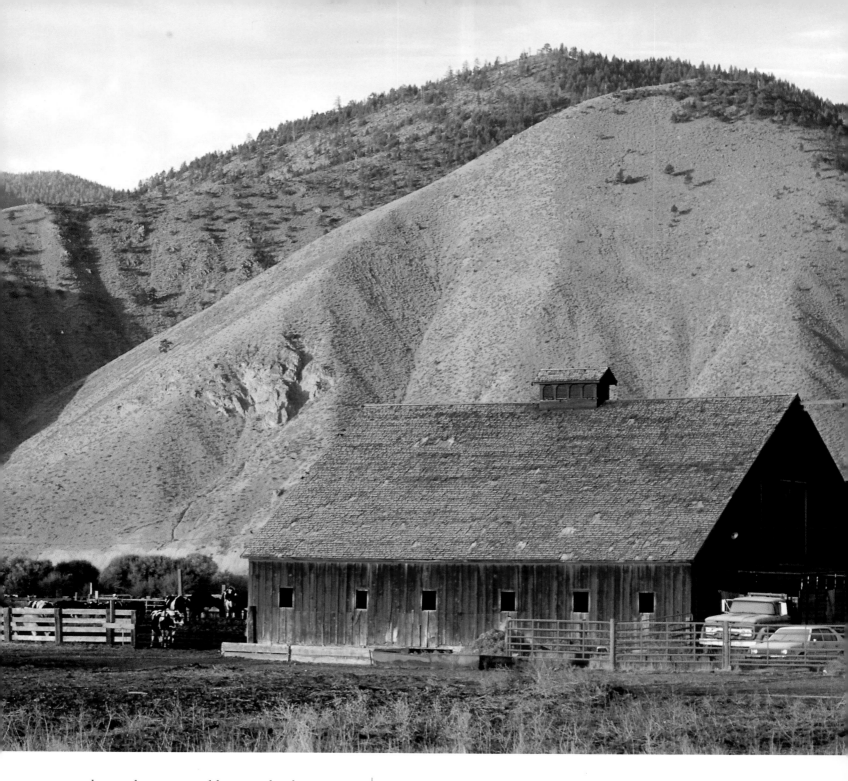

the top down, music blaring as loud as you can handle, wind blowing through your hair, sun baking the top of your head. While it's not recommended, this is a highway so uncrowded you could drive on either side of the road. If you want to stop and lie on your stomach in the middle of the road, you can. If you want to scream out your window, cursing your boss, or authority figures in general, you can.

If you want, you can. Sometimes just knowing there is a place where that's still possible is enough.

Traditional ranching survives in Carson Valley, only a few miles south of Reno.

# THE CITIES

"The Biggest Little City In The World," Reno's boastful claim is backed up by high wattage entertainment in a mountain setting.

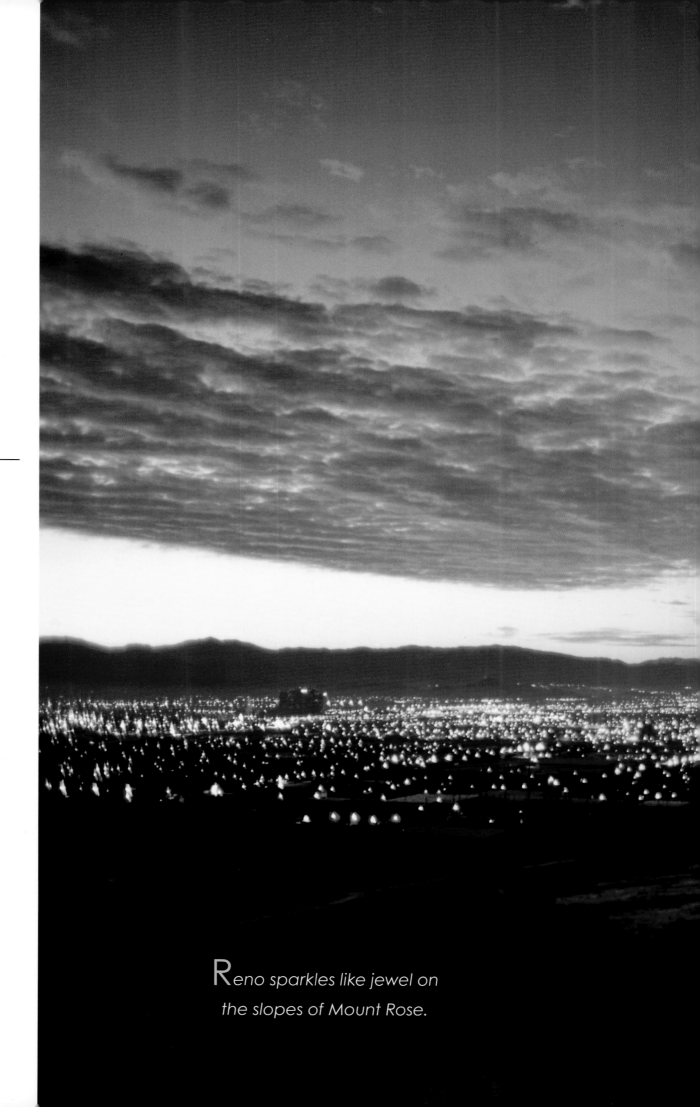

*Reno sparkles like jewel on the slopes of Mount Rose.*

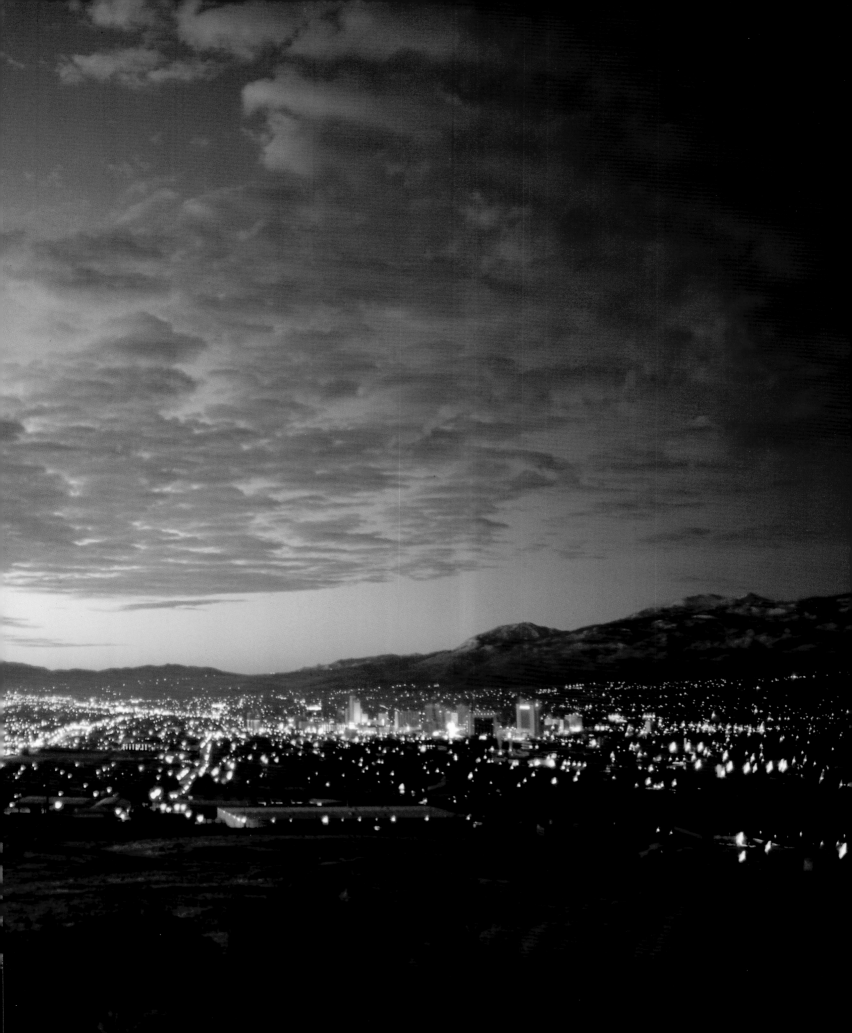

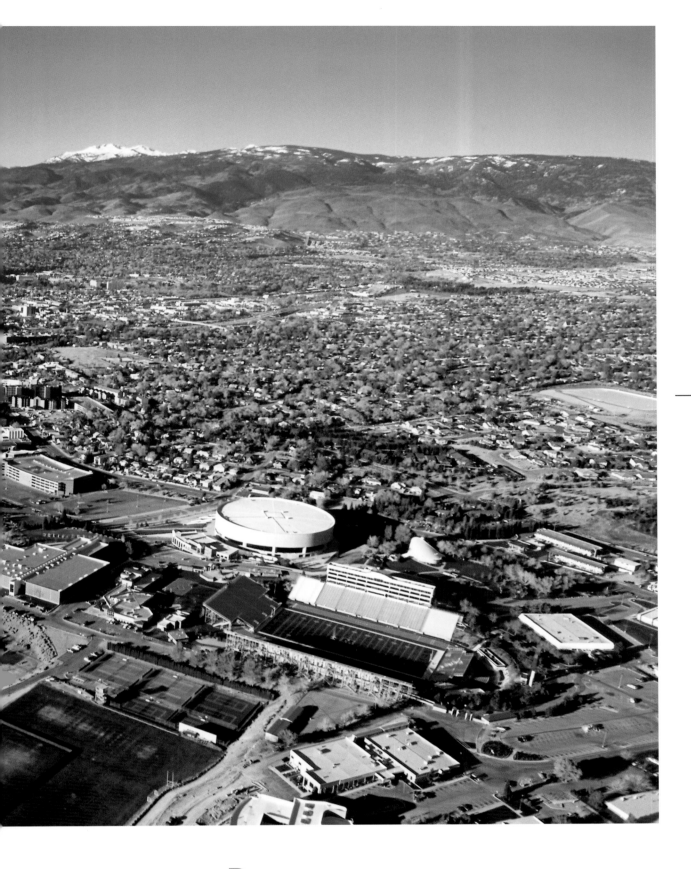

Reno's motto, "Biggest Little City In
The World," reflects urban amenities
in a not-too-sprawling setting.

Virgina City, not far from Carson
City and Reno, was built around
the mines of the Comstock Lode. It
remains a well-preserved reminder
of the state's colorful past. Below:
Art created in electric signage
along the Las Vegas strip.

A hemisphere away from France, the Eiffel Tower juts skyward at a Las Vegas casino named Paris. Above: Bally's futuristic entrance welcomes visitors.

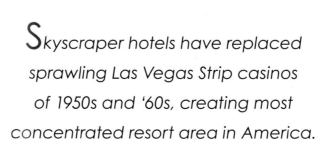

*Skyscraper hotels have replaced*
*sprawling Las Vegas Strip casinos*
*of 1950s and '60s, creating most*
*concentrated resort area in America.*

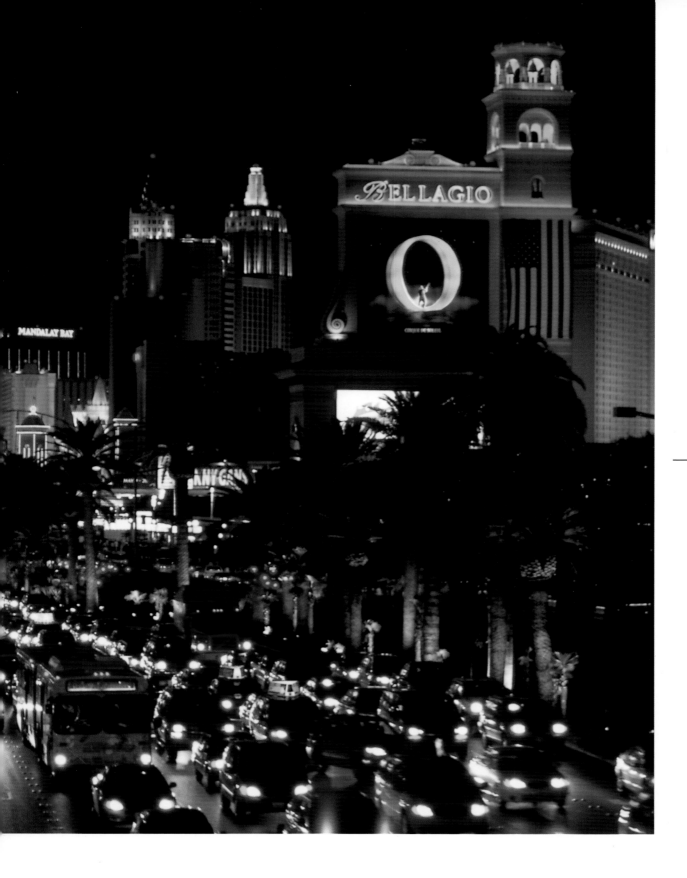

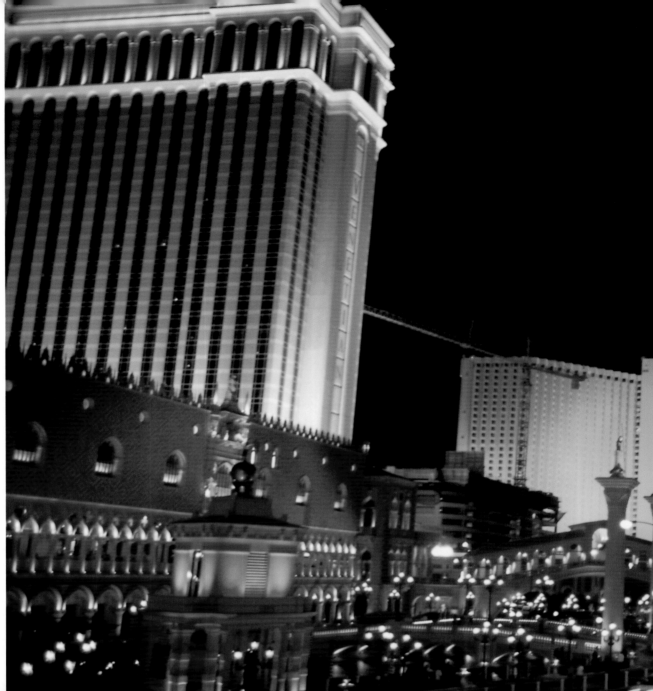

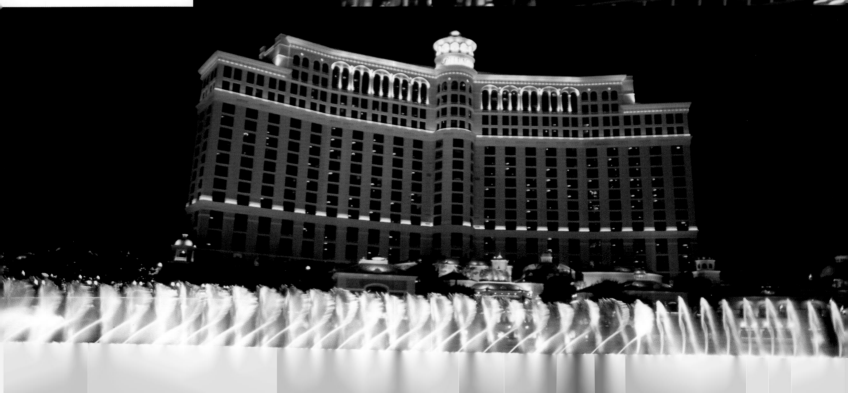

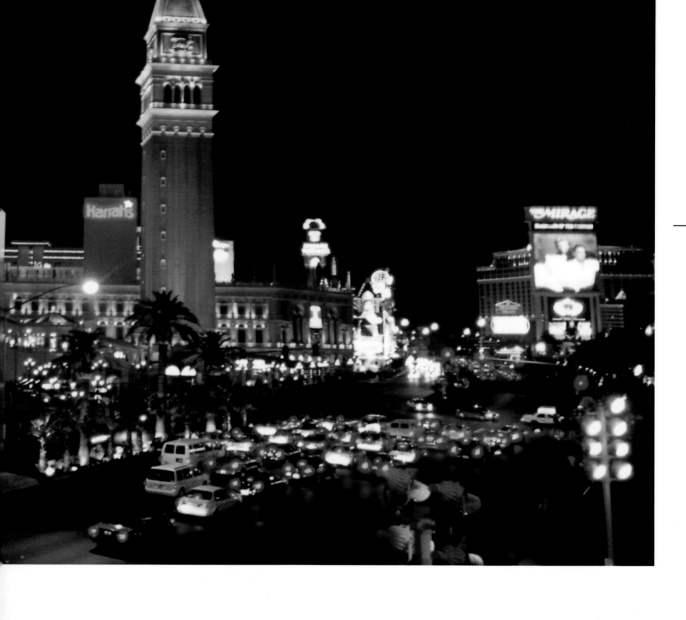

Cruising visitors halt for a stoplight
across from the Strip version of Venice.
Meanwhile, Bellagio's waterspouts
dance in synchronized grace.

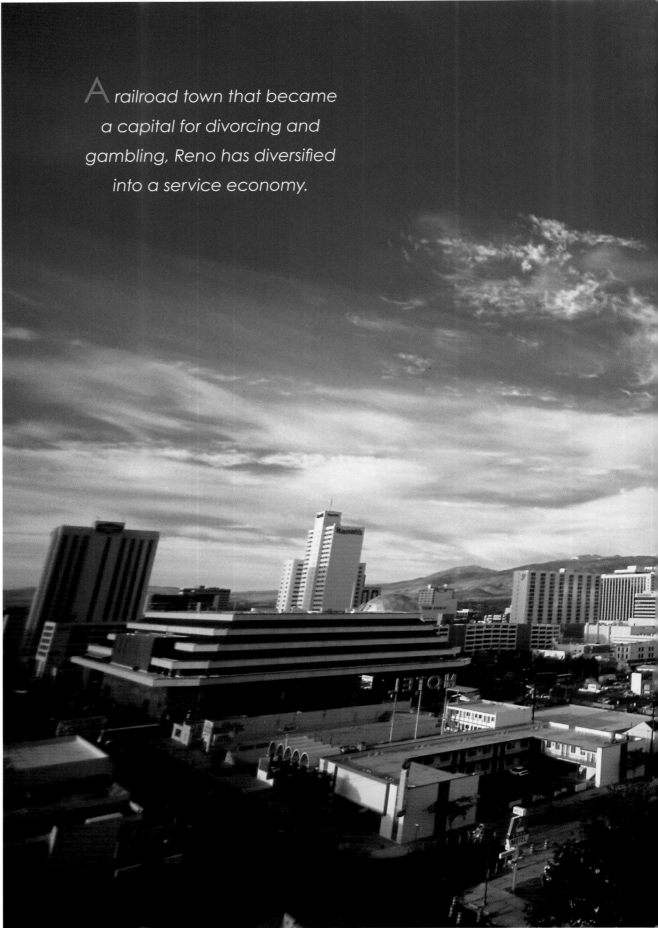

A railroad town that became a capital for divorcing and gambling, Reno has diversified into a service economy.

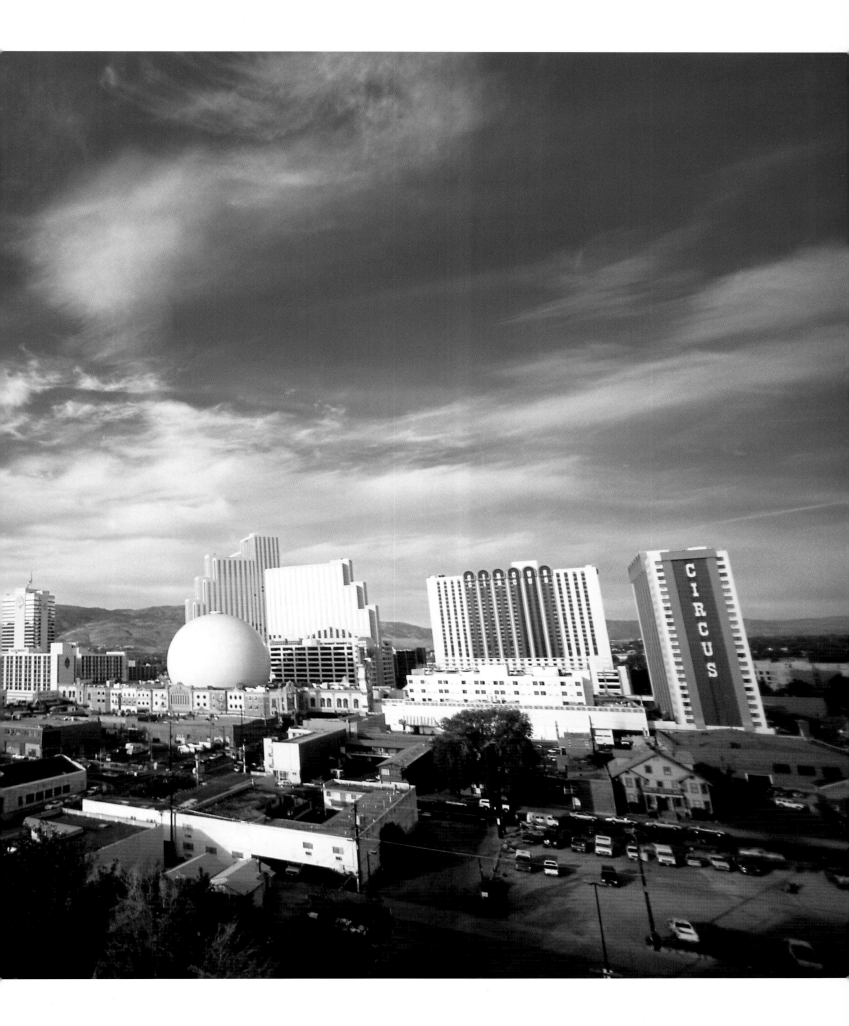

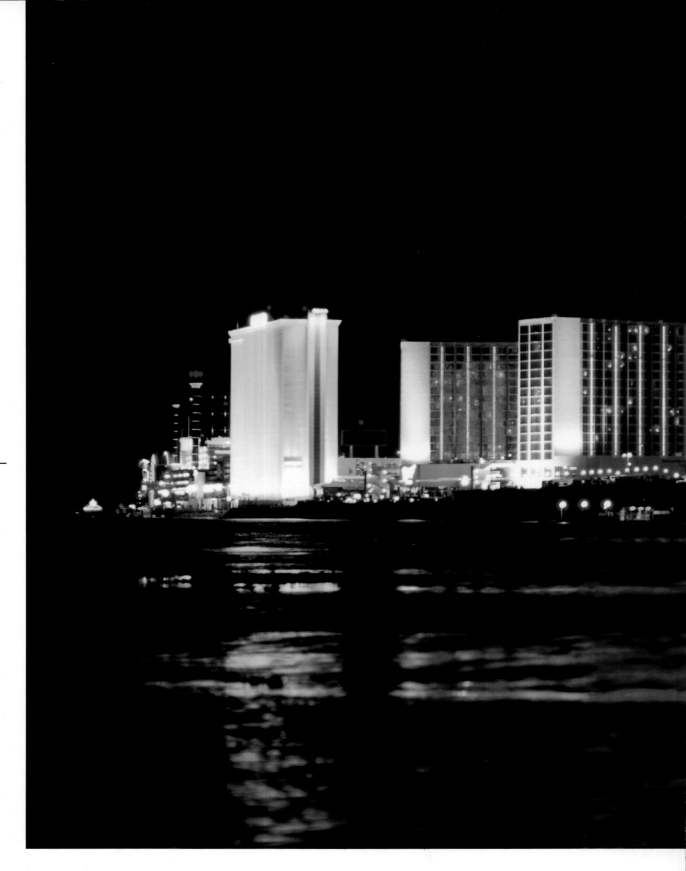

Laughlin, on banks of Colorado
River, grew out of one bankrupt
saloon in less than 40 years.

Boulder City, built to house the workers who constructed Hoover Dam, is the only town in Nevada where gambling is illegal. *Right:* The mighty Colorado river backs up behind Hoover Dam to form Lake Mead.

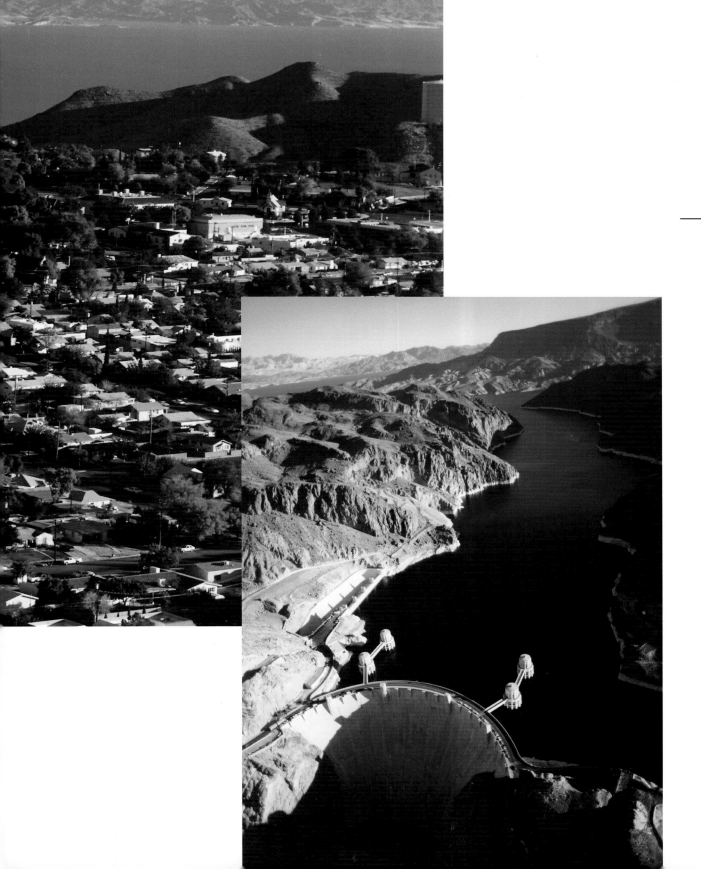

# END OF THE ROAD

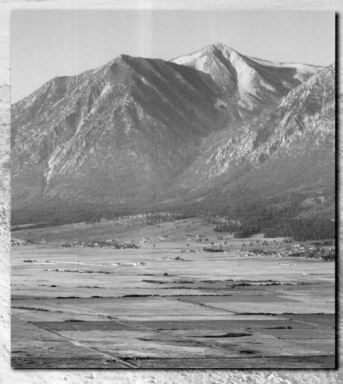

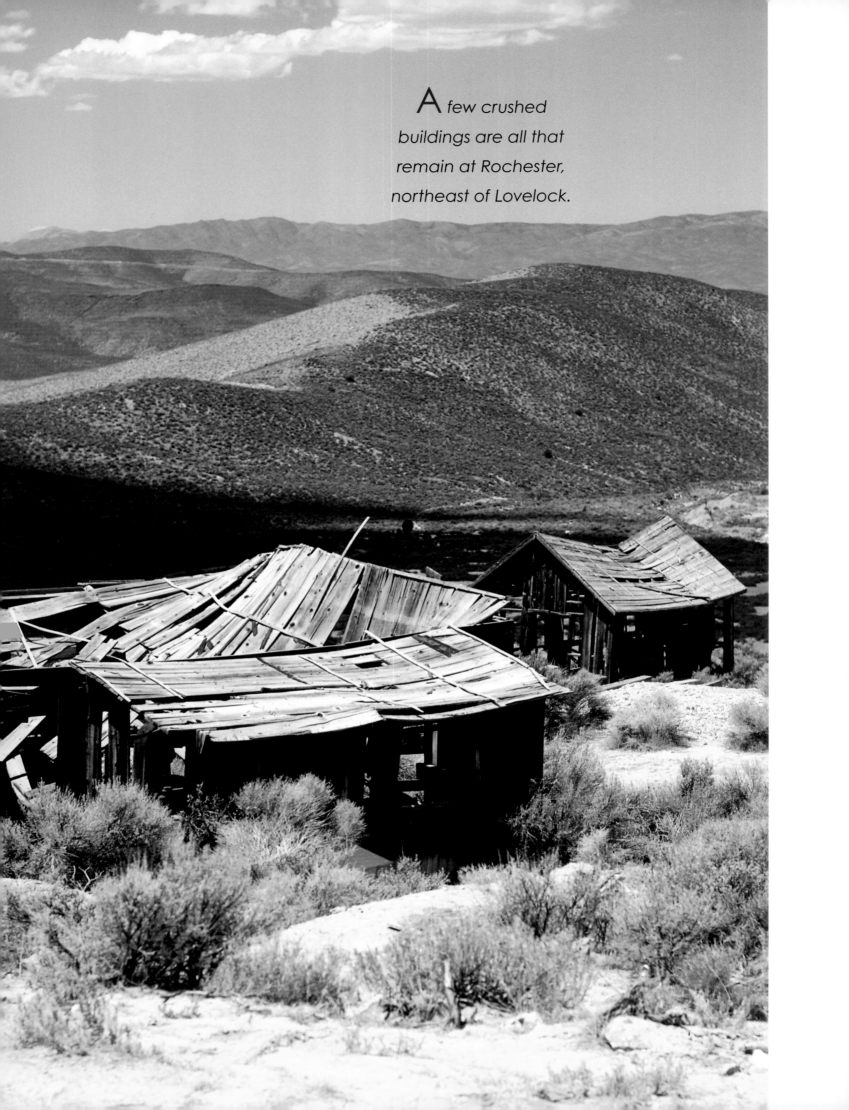

A few crushed buildings are all that remain at Rochester, northeast of Lovelock.

*" Nevada is ten thousand tales*
*of ugliness and beauty."*
*—Richard G. Lillard*

A couple of years ago, a man named Jack—a fellow Nevada history buff and ghost town hunter—told me a story. He and his wife were driving the dirt roads of eastern Nevada and stumbled upon an abandoned ranch house. On a hill overlooking the house were four graves with small, marble headstones. In a field adjacent to the house was a rusted, old automobile. Jack and his wife wandered about the property, careful not to disturb anything.

As they looked at the ranch house with its peeling paint, broken windows, and sagging roof, they wondered about the people who had lived there. Did this house see the birth of children? Was the

corral filled with horses and the yard with chickens? What kinds of delicious smells once came from the kitchen? Had the ranch been abandoned because of too many years of bad crops or drought? Or did the family tire of the backbreaking, thankless work?

While studying the old car, Jack noticed that a piece of paper had been carefully folded in quarters and placed inside one of the empty headlight cavities. Jack slowly unfolded the paper, which was brittle from exposure to the elements. On the paper, he found a poem had been carefully written. He handed it to his wife to read.

Now they knew what had happened to the old ranch.

Jack took a notebook from his car and copied the verses, then refolded the paper and returned it to its home in the broken headlight. Later, Jack would share the poem with others.

*Pause awhile to breathe a prayer*
*For the boy who loved this car.*
*He died that you might walk in freedom*
*And carry his story far.*

*He was the oldest son of the hard-*
*working rancher,*
*He loved his father and mother.*
*He learned to read in a log cabin school;*
*He was adored by sisters and brothers.*

*Heeding the call of his Uncle Sam*
*To defend his country dear,*
*And turning his back on college days,*
*He drove his old Ford here.*

*Goodbye to mother and sisters,*
*Shaking hands with Dad,*
*The rancher's son left all he loved,*
*Even the old Ford car.*

*This rancher's son who loved to read*
*Patted the car as he walked away,*
*'You sit right here and wait for me;*
*I'll drive you again someday.'*

*He fought Hitler's men awhile in France*
*Then chased the Desert Fox.*
*He rode in a Jeep that overturned;*
*They buried him in a box.*

*Many winding desert roads he'd driven,*
*Secure in the old Ford car.*
*But the open Jeep crushed the rancher's*
*son . . .*
*Another victim of that war.*

*Back on the ranch his parents mourned*
*As they buried their younger son.*
*Mercifully, they didn't yet know*
*They'd also lost their collegiate one.*

*After the war, in a flag-draped coffin,*
*The college boy came home.*
*They buried him on the western hill;*
*The old Ford car stood all alone.*

*Shock and grief take miles to heal.*
*Seeking comfort by going further,*
*They sold the ranch and left the car,*
*Awaiting the older brother.*

*When the parents died, they returned to*
*their ranch;*
*They're all on the western hill . . .*
*Grieving father and stalwart mother*
*Their younger son and his collegiate*
*brother.*

*Remember here the rancher's son*
*Who will never wander far;*
*For his body lies in the family plot,*
*Near the rusty old Ford car.*

Nevada has a way of growing on you. If you spend much time in Nevada, you begin to see beauty in the seemingly harsh, empty land. Beneath and above the bleached white grasses and pale green-gray sagebrush, juniper, and pin-yon is life—rabbits, butterflies, tortoises, lizards, chukar, eagles, and more. Tiny spring-fed, warm water ponds found on remote, scrubby flatlands teem with rare and endangered pupfish, dace, and chub.

And once you learn that the birds, bugs, fish, snakes, trees and bushes all have names, places where they like to live, and foods they like to eat, you begin to care.

Like I said, the place has a way.

A moment of beauty in Lamoille.

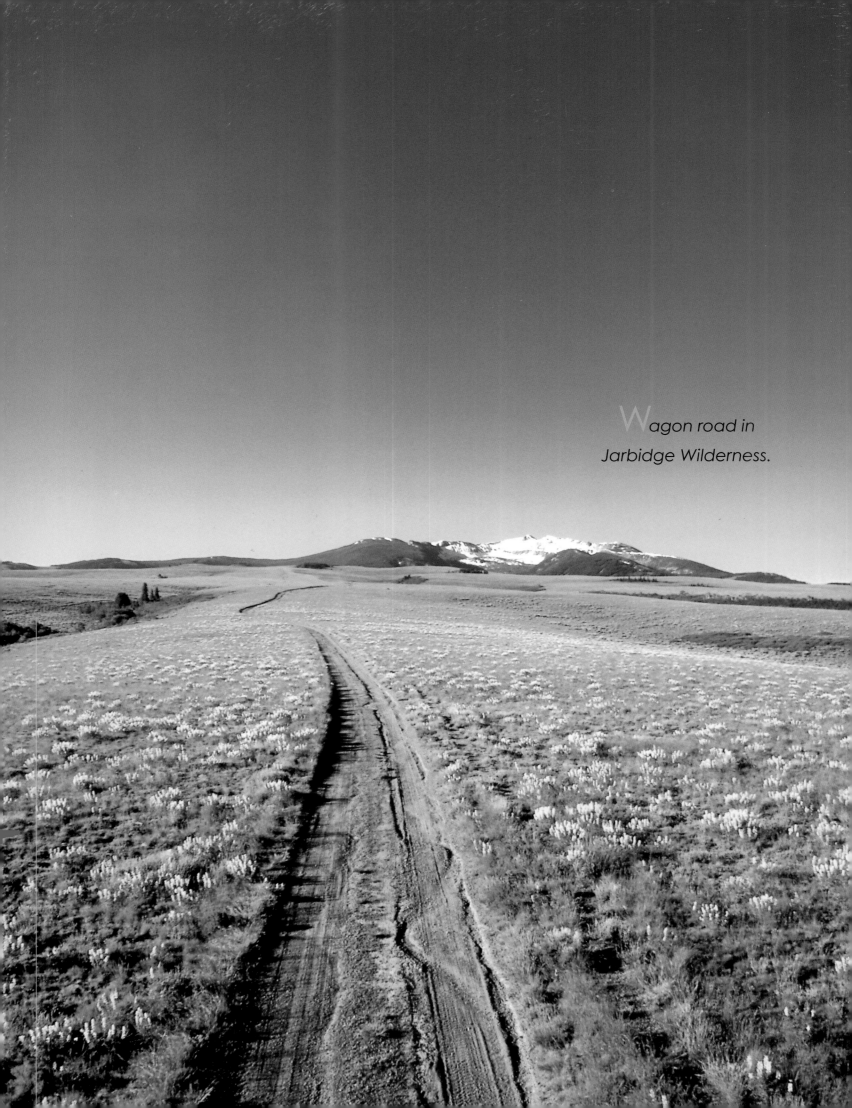

*Wagon road in Jarbidge Wilderness.*